IMAGES
of America

ALABAMA POWER
COMPANY

Mike —
I hope you enjoy
the book — no examples
of routine maintenance,
I'm afraid.

Jim Noles

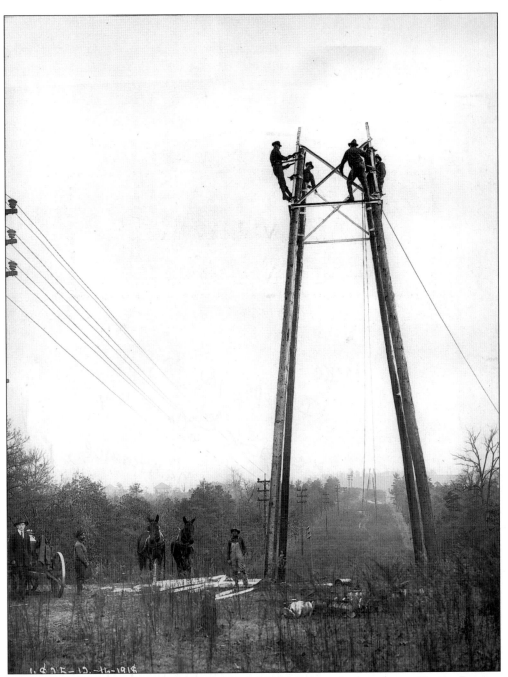

Workers string transmission lines in December of 1918, linking the brand-new Warrior Reserve Steam Plant (eventually renamed Gorgas Steam Plant) in Walker County, Alabama, with Bessemer, a suburb of Birmingham. Coal-fired power from the plant would help fuel Birmingham's burgeoning iron and steel industry, enabling companies like Sloss Industries, Tennessee Coal & Iron, ACIPCO, and U.S. Steel to eventually make Birmingham the nation's second-leading steel manufacturer. (Courtesy of APCA.)

IMAGES
of America

ALABAMA POWER
COMPANY

James L. Noles Jr.

ARCADIA

Published by Arcadia Publishing,
an imprint of Tempus Publishing, Inc.
2 Cumberland Street
Charleston, SC 29401

Printed in Great Britain.

Library of Congress Catalog Card Number: 200108815

For all general information contact Arcadia Publishing at:
Telephone 843-853-2070
Fax 843-853-0044
E-Mail sales@arcadiapublishing.com

For customer service and orders:
Toll-Free 1-888-313-2665

Visit us on the internet at http://www.arcadiapublishing.com

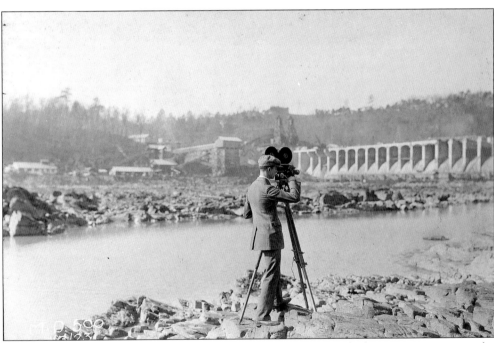

Determined to accurately tell the tale of the construction of its hydropower projects on the Coosa and Tallapoosa Rivers, Alabama Power hired a Chicago film company to record the construction effort—both to counter anti-company opinion and to "carry the message of Alabama's wonderful industrial opportunities to the people of other states." Shown at the National Exposition of Power and Mechanical Engineering in New York in 1922, the films, according to the company's monthly newsletter, did much to counter a popular national image of Alabama as "a semi-tropical state, with many swamps, cotton fields and Negroes, and a few industries." (Courtesy of APCA.)

CONTENTS

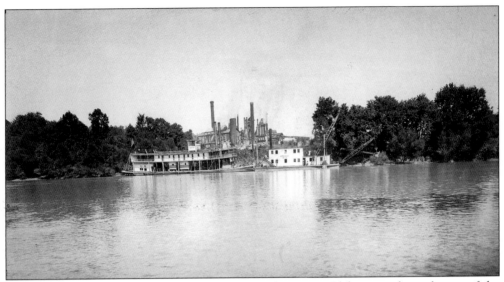

This photograph demonstrates the changing role of steam in Alabama in the early part of the 20th century—a transition from powering riverboats to providing electricity to power steel plants such as the one shown here in Gadsden. (Courtesy of APCA.)

ACKNOWLEDGMENTS

Simply put, this book would have been impossible without the cooperation of the Alabama Power Company (APC), personified in the person of Bill Tharpe, the APC's archivist. It is a rare company that recognizes its history and a rarer one that takes steps to preserve it. Alabama Power has done both, enabled to a large extent by Bill's work. Bill guided me through the archives and assisted at every step of this book's development. Throughout this process, I was following in the footsteps of Professor Harvey Jackson of Jacksonville State University. Professor Jackson's outstanding *Putting Loafing Streams to Work* remains the definitive work on the company's early hydropower developments.

In addition to Bill Tharpe, credit is due to Bill Satterfield and Steve McKinney of the law firm Balch & Bingham. Balch & Bingham and APC have cross-pollinated one another for years with talented attorneys and officers, and Bill and Steve, along with several retired partners at the firm, encouraged me in my efforts to partially illuminate the story of Alabama Power through these photographs. At APC, Executive Vice President Alan Martin was likewise supportive and gave the critical "green light" for this project. Most importantly, this work would never have been completed if it were not for the patience and support of my wife, Elizabeth.

The majority of the photographs contained in this book are taken from the APC's archives and marked "(Courtesy of APCA.)" If a photographer had noted a request for credit on a particular photograph, then that credit is also given.

INTRODUCTION

As the first decade of the 20th century drew to a close, the paths of three ambitious men—William Patrick Lay, James Mitchell, and Thomas W. Martin—crossed on the banks of Alabama's Coosa River. Whereas previous observers had viewed the Coosa and Alabama's other rivers as simply an avenue of riverboat commerce, these three men saw the steadily flowing waters in another light altogether. They realized this and other rivers, like the coal-rich hills of the state's northwest, represented a vast potential source of electric power—the power needed to complete Alabama's transformation from her post-Reconstruction agrarian somnolence and necessary to fully realize the promise of the state's abundant natural resources and infant industries.

Motivated by their shared vision, Lay, Mitchell, and Martin combined their efforts on May 1, 1912, to bring full-scale hydropower development and electricity to central Alabama with the creation of today's Alabama Power Company. Within three years, turbines were turning at what eventually became known as Lay Dam. From there, Alabama Power developed into a powerful force in the New South, not only providing energy for the state's growing iron, steel, farming, and textile industries but also bringing unprecedented comfort into the everyday lives of Alabama's citizens. As the century unfolded, the company developed other hydropower projects and coal-fired steam electricity generating plants—and later nuclear and natural gas fired plants—to provide electricity for the lower four-fifths of the entire state.

These achievements did not come painlessly. Alabama Power had its enemies. Demagogue politicians of the past found the company a convenient whipping boy in hard times as one of Alabama's so-called "Big Mules." Some of their audience—particularly receptive to their rhetoric—likely included unhappy residents of communities displaced or affected by the company's dams' rising reservoirs. On a larger stage, Alabama Power and the federal government clashed on issues ranging from private companies' hydropower rights to the role and reach of the Tennessee Valley Authority in the northern fifth of the state.

Nevertheless, most impartial observers recognized the benefits delivered by Alabama Power to the state—benefits that encompassed more than the mere provision of electricity. Alabama Power, for example, created what was to become Alabama's first licensed commercial radio station, played an active role in recruiting new industry to the state, pioneered and sponsored a variety of research endeavors, and led the way in electrifying the rural regions of Alabama. In the end, however, the delivery of electricity to homes where before there was none might rank as the company's proudest accomplishment. The transformation electrical service wrought on

Alabama households in the first half of the 20th century was nothing short of revolutionary.

A contemporary of William Patrick Lay described the impact of the newly delivered electricity on Alabama's homes: "The housekeeper, once burdened with duties which required practically her whole time, suddenly found a whole new freedom. Labors that once required hours of manual effort became possible of performance in minutes by the use of electricity. Even in the most isolated community the electric light took the place of the old-fashioned lamps that once had to be cleaned and filled each day; carpet sweepers supplanted the ancient method of hauling rugs into the open and beating the dust out of them by hand . . . in a multiplicity of ways the toil and burden and physical exhaustion incident to housekeeping was minimized." (Hornaday, John Randolph. *Soldiers of Progress and Industry.* New York: Dodd, Mead & Company, 1930.)

Perhaps today these benefits are taken for granted in the South's homes. It is the hope of this author, however, that through the historical glimpses provided by the photographs within, at least some sense of the price and effort expended in bringing us to the present state of affairs can be recognized. With that in mind, this book is not simply a brochure illustrating the APC's current facilities and operations. Rather, it is a glimpse of how the APC arrived at where it is today. At the same time, it must be understood that this work is not a comprehensive study or history of the Alabama Power Company. Focused almost exclusively on the collection of black-and-white photographs in the company's archives, *Alabama Power Company* neglects several key projects and individuals, such as the construction of Farley Nuclear Plant and the founding of the Southern Research Institute. It is hoped that this slight will be forgiven—it is simply a reflection of the photographs readily available in the corporate archives.

James L. Noles Jr.
March 12, 2001

One
"SOLDIERS OF PROGRESS AND INDUSTRY"

A Gentleman who, for more than half a century has steadfastly pointed out the value of the development of Alabama's internal waterways and hydro-electric power.

Capt. William P. Lay was the third in a line of Alabama river men. His father had been the only riverboat captain to run the length of the rapids-infested Coosa River, doing so to keep his riverboat, the *Laura Moore*, out of the hands of advancing Yankee troops. Appreciative of his father's wartime difficulties, Lay formed the Coosa-Alabama River Improvement Association in 1890 to develop the rivers' navigation potential. (Courtesy of APCA.)

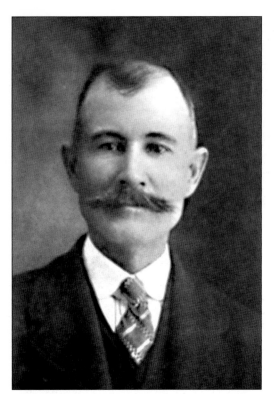

As investors cooled on the Coosa's potential for barge commerce, William Lay looked to other ways to capitalize on the river's flowing waters and, on December 4, 1906, he and his associates formed the Alabama Power Company. Armed with only $5,000 in capital and congressional authorization to build a dam at Lock 12 on the Coosa, he struggled to find investors willing to support his plans. (Courtesy of APCA.)

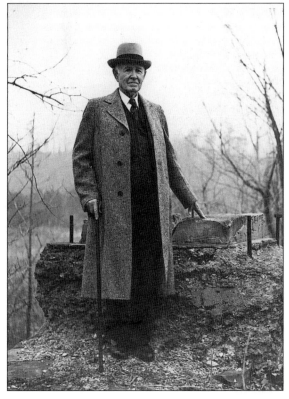

As 1911 drew to a close, William Lay (shown here in 1940) realized the APC, in its current form, lacked adequate financing to construct a dam at Lock 12. With his congressional authorization to construct a dam on the Coosa River about to expire, he searched for other means to fulfill his dream of bringing hydropower to the region. He found it in James Mitchell. (Courtesy of APCA.)

James Mitchell, a Canadian-born, Massachusetts-raised electric power engineer and developer, representing the London banking house of Sperling and Company, possessed the financial connections and hydropower development experience to salvage Lay's vision. He was destined to become the revitalized APC's first president. (Courtesy of APCA.)

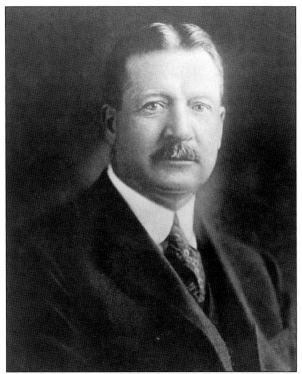

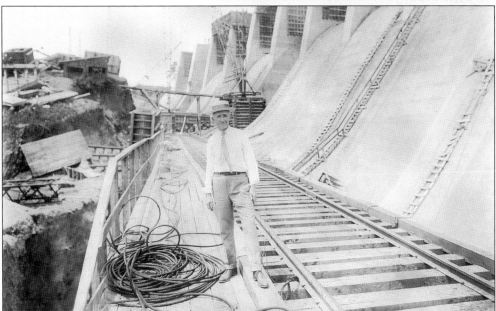

Thomas W. Martin, shown here at what would become Jordan Dam, was an Alabama attorney representing Montgomery-area hydropower interests. Combining forces with Mitchell, the two men rescued Lay's foundering effort on May 1, 1912, by transferring the Alabama Power Company's holdings to the Alabama Traction, Light and Power Company, Ltd., which had been organized as the holding company for the now-revitalized Alabama Power Company. (Courtesy of APCA.)

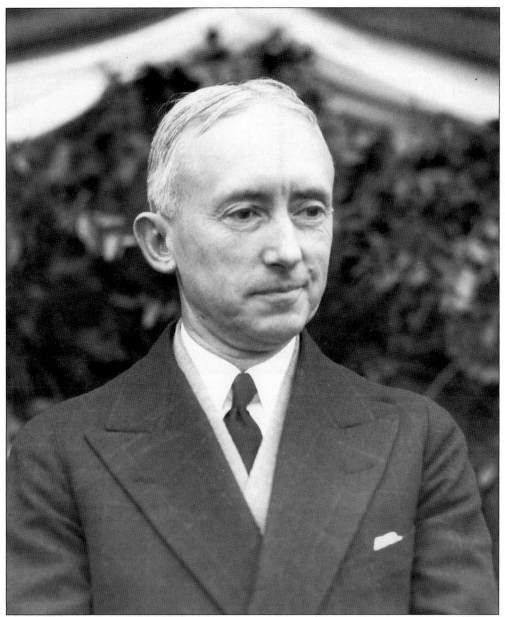

Thomas Martin, born in Scottsboro, Alabama, initially served as Alabama Power Company's chief counsel. His and Lay's familiarity with the lands around the Coosa and Tallapoosa Rivers was invaluable as APC purchased the vast tracts necessary for its proposed dams' impoundments. Later, after James Mitchell suffered a paralytic stroke, Mitchell handpicked Martin to be his successor. The 39-year-old Martin became the APC's second president on February 16, 1920. Martin, according to James F. Crist, in his book *They Electrified the South*, was "a tiny man, possessed of an enormous ambition to do big things and a rare ability to get others to pitch in with him . . . he was ambition incarnate, but he had courage and unshakable integrity . . . " He served as the chairman of the APC's board of directors from 1949, when today's Southern Company acquired the stock of Alabama Power Company, until a year before his death in 1964. (Courtesy of APCA.)

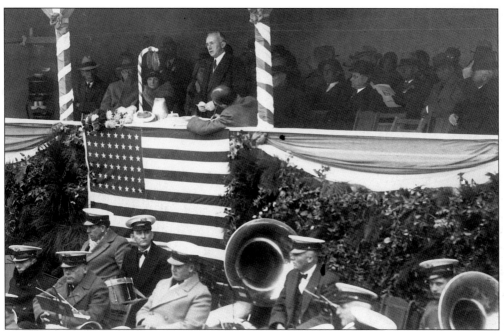

On November 29, 1929, Thomas Martin (speaking) presided over the dedication of the dam at Lock 12 as the Lay Dam and Hydroelectric Generating Plant. The dam was named after William Patrick Lay, who, along with his attorney and friend Oliver Hood and William's son Earl, had founded the first Alabama Power Company in 1906. (Courtesy of APCA.)

With the outbreak of World War I, the flow of investment dollars from Canada and England secured by James Mitchell began to diminish. Fortunately, Reuben A. Mitchell (no relation to James, left) and his brother Sidney Z. Mitchell (right), Alabama-born financiers and electric power developers, stepped forward with additional financing. A grateful APC dedicated its Jordan Dam in honor of their mother, Elmira Jordan, in 1927. (Courtesy of APCA.)

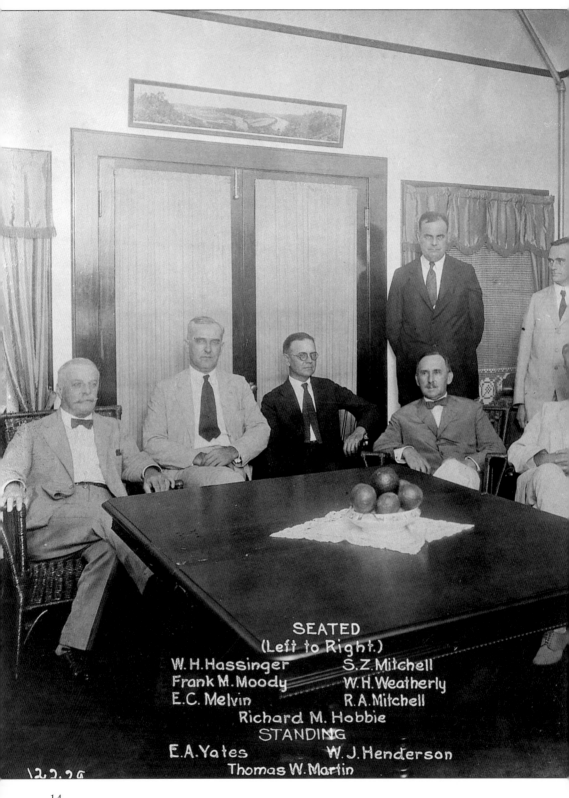

SEATED
(Left to Right.)

W. H. Hassinger S. Z. Mitchell
Frank M. Moody W. H. Weatherly
E. C. Melvin R. A. Mitchell
Richard M. Hobbie

STANDING

E. A. Yates W. J. Henderson
Thomas W. Martin

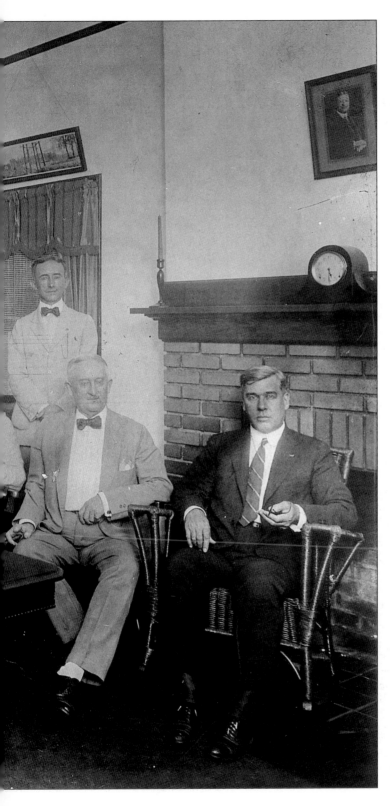

In 1923, the APC's board of directors met at Lay Dam. Shown from left to right are the following: (front row) W.H. Hassinger, Frank M. Moody, E.C. Melvin, Sydney Z. Mitchell, W.H. Weatherly, Reuben A. Mitchell, and Richard M. Hobbie; (back row) Eugene A. Yates, W.J. Henderson, and Thomas Martin. A year later, in 1924, a new holding company, Southeastern Power & Light Company, took control of APC. Commonwealth & Southern Company would follow it five years later. (Courtesy of APCA.)

William Logan Martin Jr., the younger brother of Thomas Martin, became the APC's general counsel in 1920 while a member of the Birmingham firm of Martin & Blakely (today's Balch & Bingham). A graduate of the United States Military Academy and the University of Alabama's School of Law, he had served as Alabama's attorney general prior to becoming APC's lead attorney. (Courtesy of Harold Williams.)

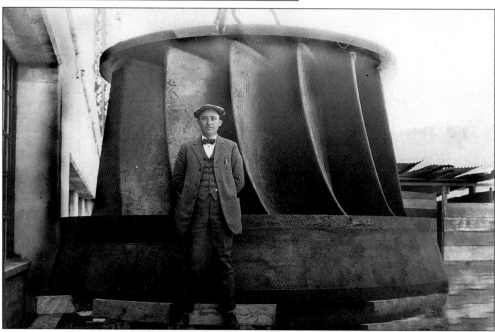

C.C. Davis, standing in front of a turbine wheel at Mitchell Dam in 1923, served as the field superintendent who managed the construction of Mitchell, Martin, and Jordan Dams for the Dixie Construction Company, Alabama Power Company' construction subsidiary. The "C.C." reportedly stood for "Careful Charlie," and Davis was a well-respected member of APC's management team known for his hard work, competence, and focus on employee safety. (Courtesy of APCA.)

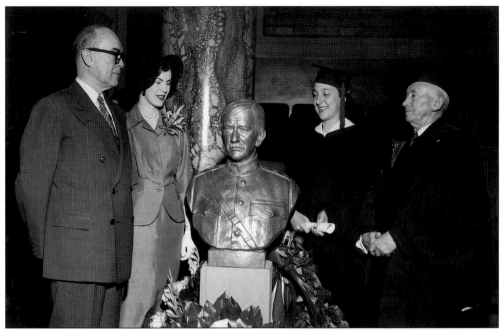

Thomas Martin (left) attends the dedication of a bust of William Crawford Gorgas at New York University in 1951. When lawsuits alleged APC's Lay Dam reservoir had created a breeding ground for malaria-bearing mosquitoes, APC called the Alabama native, famous for combating malaria in the Panama Canal Zone, to examine the situation first-hand. Gorgas's expert testimony absolved APC's reservoirs and forestalled over 1,100 pending lawsuits. A grateful APC later renamed its Warrior Reserve Steam Plant in his honor. (Courtesy of APCA; photo by Frank J. Gilloon Agency.)

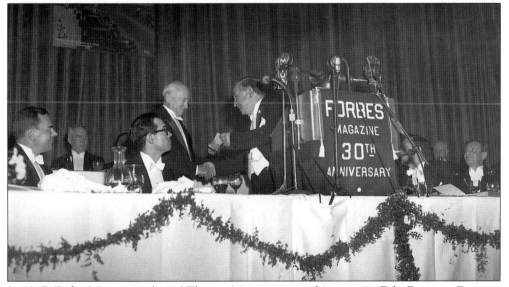

In 1947, Forbes Magazine selected Thomas Martin as one of America's "Fifty Foremost Business Leaders," calling him "a symbol of a new, aggressive industrial South." He shared this illustrious distinction with such noted businessmen as Henry Luce, Harvey Firestone, Henry Ford II, and Nelson Rockefeller. (Courtesy of APCA; photo by David Burns.)

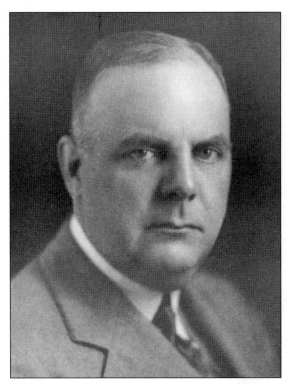

Eugene A. Yates, as chief engineer, oversaw the construction of the Coosa River's Lay Dam, the company's first hydroelectric project, in 1912, and also supervised the construction of Gadsden Steam Plant. He later served as one of APC's vice presidents and general manager from 1921 to 1930. An appreciative APC named Yates Dam, on the Tallapoosa River, in his honor. (Courtesy of APCA.)

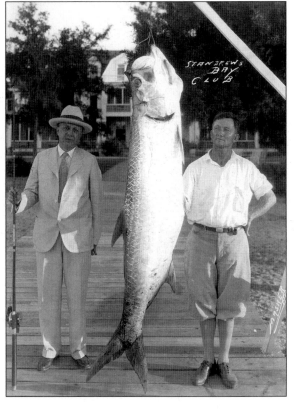

Fernand C. Weiss, pictured on the left, stands beside his catch at St. Andrews Bay Club. The dam and lake that would eventually be named in his honor in northeastern Alabama is now known for world-class fishing for a significantly smaller trophy—crappie. Weiss became APC's chief engineer in 1931 and later became its vice president in charge of engineering and construction. (Courtesy of APCA.)

18

Fernand C. Weiss speaks on the occasion of the Weiss Dam groundbreaking on April 26, 1958—an event at which 10,214 plates of barbeque were served to the assembled crowd. Weiss Dam, on the Coosa River, would eventually impound a 30,000-acre lake when it was completed in 1961. (Courtesy of APCA.)

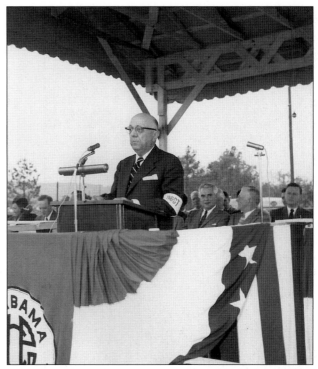

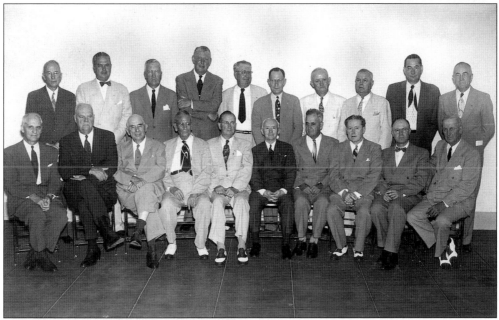

APC's board of directors meets at the dedication of the rebuilt Gadsden Steam Plant on September 16, 1949. Pictured from left to right are the following: (front row) James M. Barry, E.A.Yates, R.E. Thomas, Algernon Blair, B.L. Noojin, Thomas Martin, W.H. Smith, Gordon D. Palmer, Ervine Jackson and J.L. Bedsole; (back row) Carl James, Crawford Johnson III, Gen. John C. Persons, A.M Shook III, Walker Reynolds, E.W. Robinson, J. Finley McRae, W.C. Bowman, John C. Webb, and Lewis M. Smith. (Courtesy of APCA.)

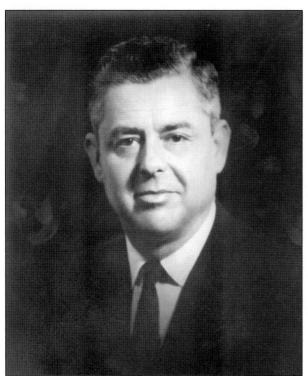

Edwin I. Hatch left the law firm of Martin, Blakey & Hatch (a precursor to today's Balch & Bingham) in 1955 to become a vice president, and later an executive vice president, with Alabama Power Company. He later became president of Georgia Power Company from 1963 to 1975. Georgia Power Company's Hatch Nuclear Plant is named in his honor. (Courtesy of APCA.)

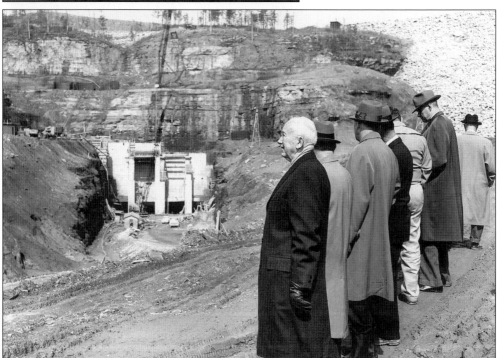

Thomas Martin and a group of visitors inspect construction progress at what will become the Lewis M. Smith Hydroelectric Generating Plant and Dam on the Sipsey Fork of the Black Warrior River, c. 1960. (Courtesy of APCA.)

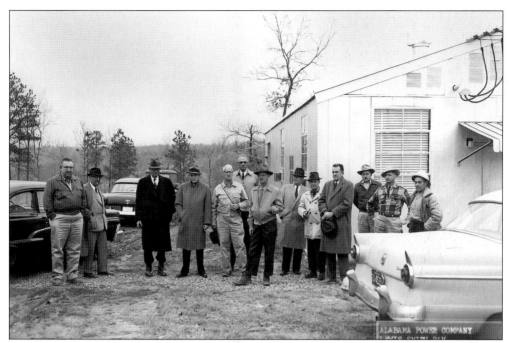

Company officers and consultants meet at the Smith Dam construction crew's bunkhouse on January 1, 1959. Pictured from left to right are Ed Waggoner, Fernand C. Weiss, J.P. Growden, Ed Harrison, D.J. Bleyfuss, Spike Harris, Doug Elliot, Ernest C. Gaston, Ned Coulbourn, Dick Randolph, Jim Tyson, Lewis Bond, and John Skinner. (Courtesy of APCA.)

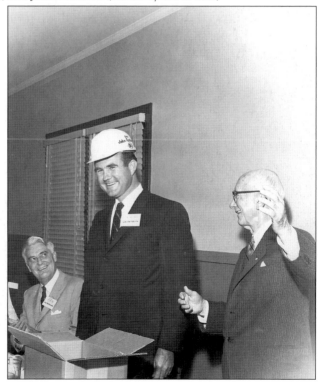

An amused Thomas Martin presents Alabama governor John Patterson with a company hard hat. Although no longer the company's president, Martin remained on as chairman of the APC's board of directors. To Patterson's right sits Walter Bouldin, who served as APC's president from 1957 to 1969. (Courtesy of APCA.)

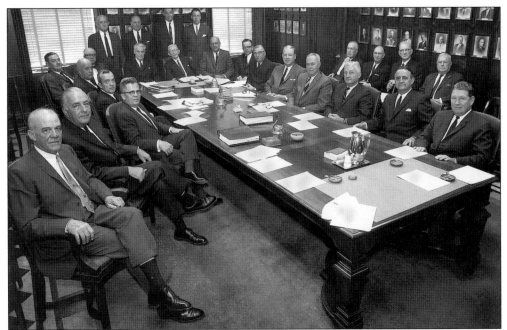

New and retiring members of APC's board of directors meet on April 15, 1963. From left to right (sitting) are Everett Lay, H. Neely Henry, William H. Murfee, Alvin W. Vogtle Jr., Marshall K. Hunter, Walter Kennedy, Ervin Jackson, Walter Bouldin, Thomas W. Martin, Frank M. Moody, T. Massey Bedsole, John A. Hand, W. Cooper Green, Crawford Johnson III, Earl McGowin, L.Y. Dean III, D.H. Morris III, W.C. Bowman, J.L. Bedsole, M.E. Wiggins, and Gen. John C. Persons; (standing) J. Finley McRae, William J. Ruston, John C. Webb, and Harlee Branch Jr. (Courtesy of APCA.)

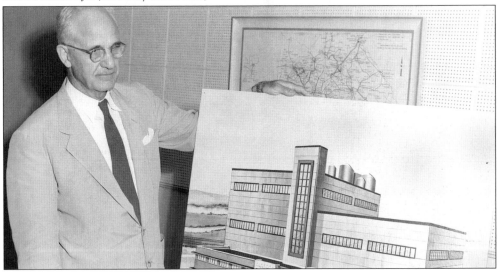

James M. Barry, in 1958, poses beside an artist's conception of the electric generating steam plant to be named in his honor outside of Mobile. Barry succeeded Martin as APC's president in 1949 and served until 1952. He was "a utility man's utility man . . . He was among the men who literally built Alabama Power," according to James Farley, a subsequent president. (Courtesy of APCA.)

Alvin W. Vogtle Jr. served as an attorney for APC and then joined it as an executive vice president in 1962. Seven years later he became the president of Southern Company, which by then was Alabama Power's parent company. As an imprisoned pilot in World War II, his numerous attempts to escape reportedly provided the inspiration for Steve McQueen's character in the movie *The Great Escape*. Georgia Power Company's Vogtle Nuclear Plant is named in his honor. (Courtesy of Harold Williams.)

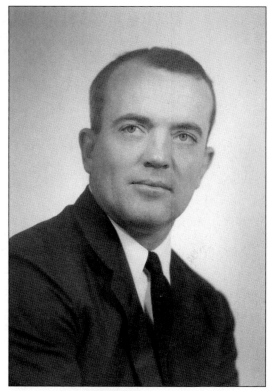

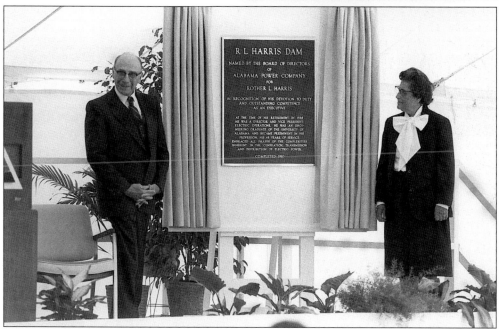

Rother L. "Judge" Harris and his wife, Hattie, attend the dedication of the dam named in his honor in 1983 on the Tallapoosa River. When Harris retired from the APC in 1968, he was a member of APC's board of directors and its vice president for Electric Operations. (Courtesy of APCA.)

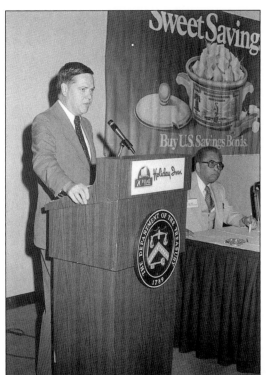

Joseph M. Farley addresses a group of Birmingham-area businessmen during the 1979 Savings Bond campaign. Originally with APC's longtime law firm, Balch & Bingham, Farley had gone in-house with APC in 1965, eventually serving as its president from 1969 to 1989 and shepherding it through difficult and challenging times. Farley Nuclear Plant, operating outside of Dothan, Alabama, is named in his honor. (Courtesy of APCA.)

Today, Alabama Power Company is led by Elmer Harris. Serving as APC's president since 1989, he was recognized by the *Birmingham News* in 1999 as "one of a new generation of leader, the activist executive with an agenda for community change." Harris's first work experience with APC came in 1958 as an Auburn University engineering co-op student. (Courtesy of Alabama Power Company).

Two

HYDROPOWER

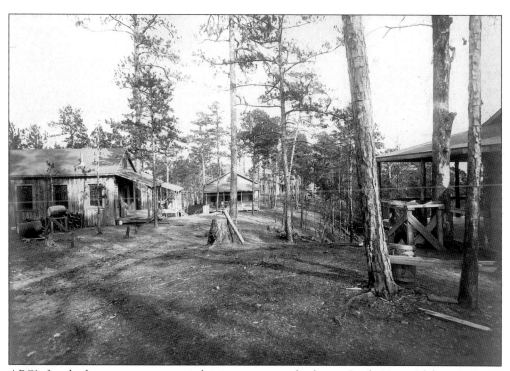

APC's first hydropower project was the construction of a dam at Lock 12 on Alabama's Coosa River. APC contracted with the MacArthur Construction Company of New York to build the dam, to be eventually named Lay Dam. Shown here are the engineers' buildings in the construction camp. (Courtesy of APCA.)

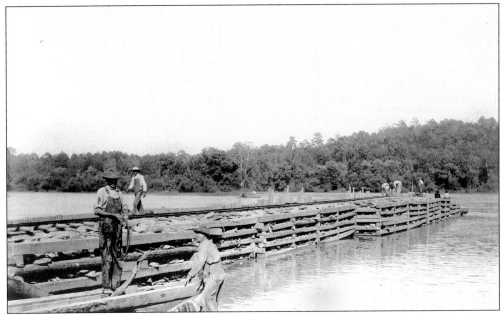

Construction of Lay Dam began in 1912. The workers shown in this photograph are building a cofferdam to divert the river from work areas. The wooden beams they are using represent just some of the 6.6 million feet of lumber eventually required in the construction of the dam. (Courtesy of APCA.)

An important step in the construction of a dam, such as the one at Lock 12, was the removal of timber and brush from the dam's future 4,700-acre impoundment. Although perhaps unnecessary, as historian Harvey Jackson reported, the APC recognized that the "respect" of neighboring landowners "for the law, in so far as it may assist them in obtaining compensation for imagined damage, made it appear prudent to clear the reservoir." (Courtesy of APCA.)

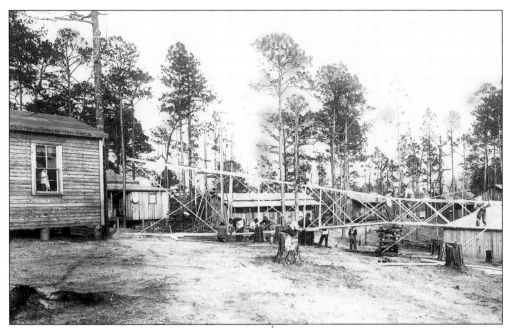

Of course, a hydropower-generating project isolated from its customers would serve no purpose. Consequently, as the construction at Lay Dam progressed, so did the fabrication and installation of the Type A transmission line towers necessary to deliver electricity to APC's distant customers. (Courtesy of APCA.)

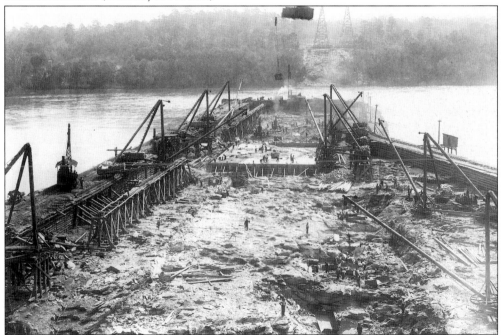

This photograph, taken in April of 1913, shows the excavation of the ground for the Lay Dam's draft tubes in the foreground. Beyond the excavation work, workers pour concrete in the dam's second section. Notice the pulleys used for transporting material from one side of the Coosa to the other. (Courtesy of APCA.)

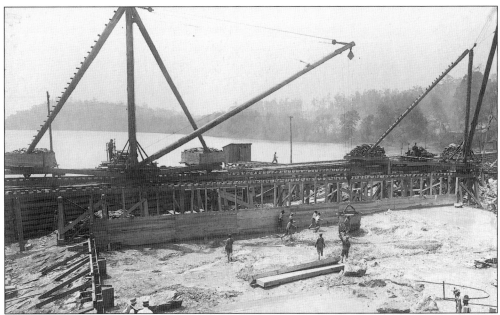

Workers pour concrete for the foundation of the dam's powerhouse. The men toiling at Lay Dam represented a mix of the American population—Eastern European immigrant labor imported by MacArthur Construction from New York, locals hired in neighboring Chilton County, African Americans brought in from Memphis, Mississippi, and Birmingham, and Swedish and Italian craftsmen recruited from Northern cities. (Courtesy of APCA.)

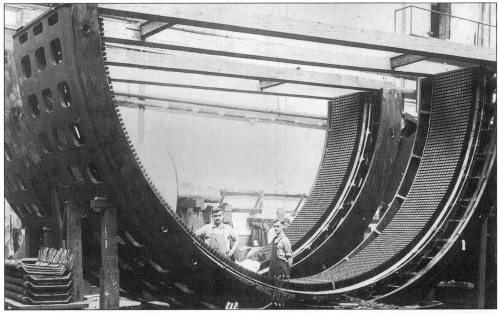

Shown here is an inside view of a generator stator, soon to be installed at Lay Dam. Propelled by the force of water rushing through a wheel mechanism below, the generator's turbine rotors turned within the fixed copper stator, causing an electrical voltage to be induced in the stator's windings. In that manner, APC converted the force of the river's rapids to electricity for a power-hungry Alabama. (Courtesy of APCA.)

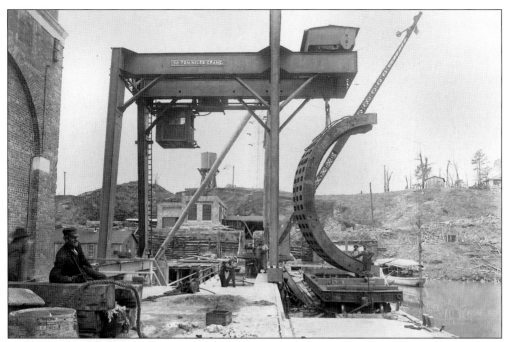

A crane carefully unloads the generator frame for Lay Dam's Unit No. 5. Although the dam's first unit was in operation by 1914, expansion of the successful project continued in 1917. (Courtesy of APCA.)

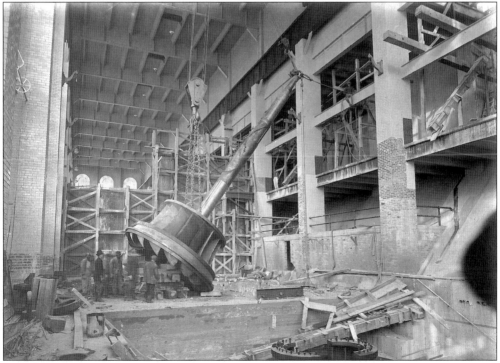

Under the watchful eyes of engineers and workers, a crane lowers the water wheel runner for Lay Dam's Unit No. 5 into place. (Courtesy of APCA.)

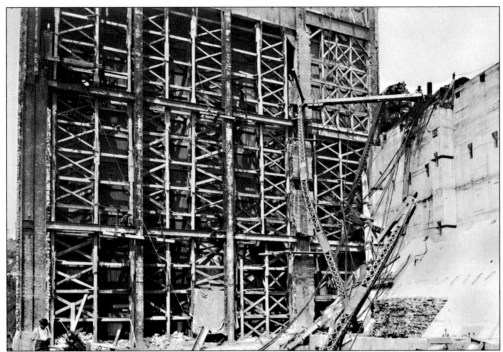

Despite APC's best efforts, work did not always progress smoothly at Lock 12, as evident by the collapse of this traveling crane in 1916. In all, 382 accidents and 6 fatalities marred the initial construction of Lay Dam, reportedly considered to be a "very reasonable" number by the standards of the time. (Courtesy of APCA.)

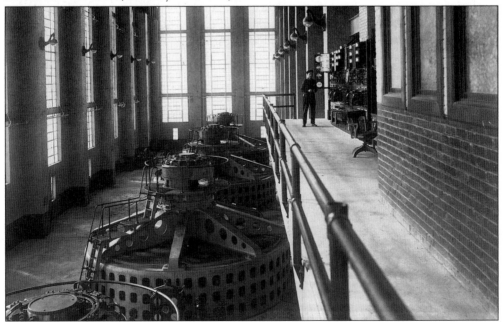

The first of the Lay Dam units, shown here inside the dam's completed powerhouse, went into service on April 12, 1914, approximately 20 months after construction had commenced. (Courtesy of APCA.)

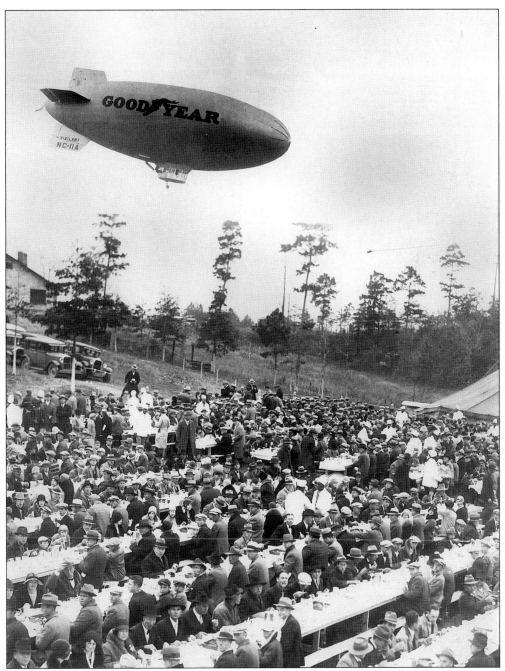

A large crowd gathered under the watchful eye of the Goodyear blimp *Vigilant* on November 29, 1929, on the banks of the freshly tamed Coosa River. There, they enjoyed barbeque and commemorated APC's dedication of the dam at Lock 12 to William Patrick Lay. (Courtesy of APCA.)

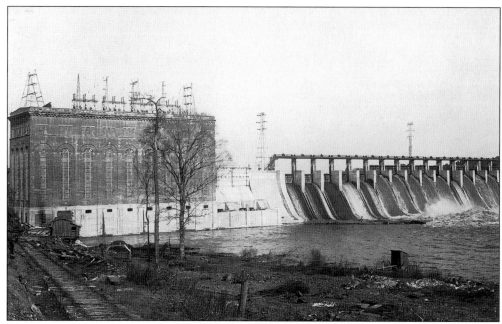

The completed Lay Dam marked the fruition of its namesakes' vision—to bring the benefits of hydropower to central Alabama. Today, the dam's three General Electric turbines are capable of delivering a generating capacity of 29,500 kilowatts each. (Courtesy of APCA.)

In 1965, as part of the APC's Coosa River Project, Lay Dam was extensively redeveloped. By then, diesel cranes and pickup trucks had replaced the steam shovels and mules that had served the dam's first construction force. (Courtesy of APCA.)

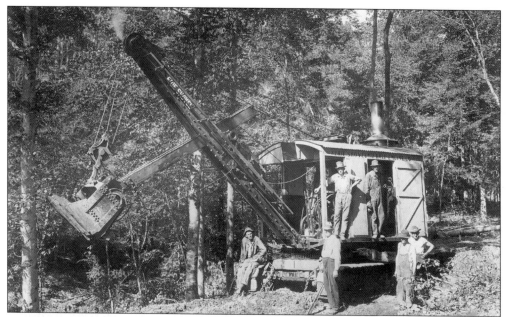

Following the success of Lay Dam, APC's next hydropower project was located 14 miles downstream from Lay Dam, at Duncan's Riffle. This time, however, work crews such as the steam shovel operators shown here were part of the Dixie Construction Company, Alabama Power Company's own construction subsidiary. Salaries for its workers in 1920 started at 25¢ an hour. (Courtesy of APCA.)

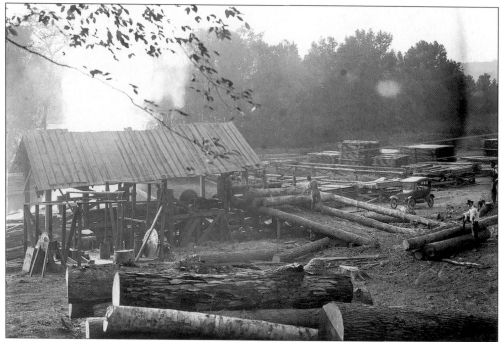

Construction of APC's dam at Duncan's Riffle required numerous ancillary operations, such as quarry mining, laying of railroad track, and the operation of at least two saw mills to provide the massive amount of lumber necessary for the dam's concrete forms. (Courtesy of APCA.)

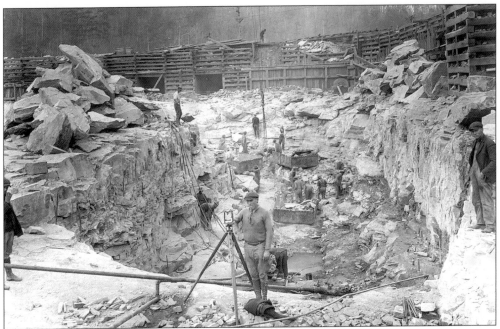

Construction at Duncan's Riffle of what would eventually become Mitchell Dam began in 1920—perhaps somewhat prematurely, given the absence of a federal permit at the time! One was obtained, however, and construction resumed. This photograph shows excavation and survey work behind the project's sheltering cofferdam. (Courtesy of APCA.)

Throughout the construction and subsequent operation of the Coosa River dams, malaria posed a threat to the health of workers and their resident families in the on-site work camps. To combat this threat, APC bred and released mosquito larvae-eating *Gambusia* minnows in special ponds at the construction camps and in the neighboring area. It coupled this effort with free preventative medical care to its workers, their families, and local residents. (Courtesy of APCA.)

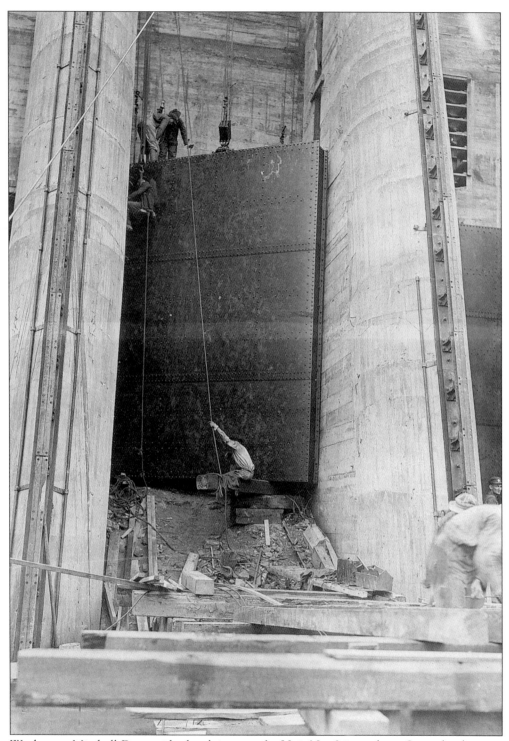

Workers at Mitchell Dam guide the sluice gate for Unit No. 2 into place. Once the dam was completed, these gates would be dropped and the dam's 5,850-acre reservoir would begin to fill. (Courtesy of APCA.)

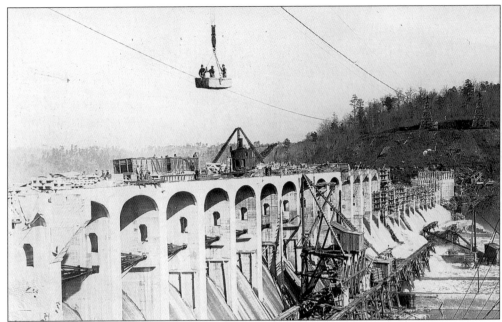

This photograph provides a general view of the progress of construction at Mitchell Dam by January 4, 1922. Note the men in the pulley car high above the dam. Those kind of daily risks associated with a construction project of that magnitude eventually cost 15 lives in the year that followed. (Courtesy of APCA.)

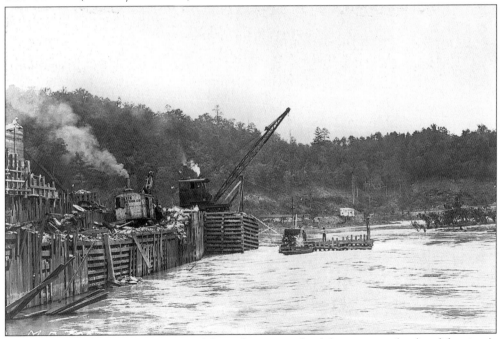

After two cofferdams were constructed (one abutting each of the opposing banks of the river), construction on Mitchell Dam's third and final cofferdam began, as shown in this photograph. This was challenging work for the men of the Dixie Construction Company, located in the deepest channel of the river and beset by rushing waters. (Courtesy of APCA.)

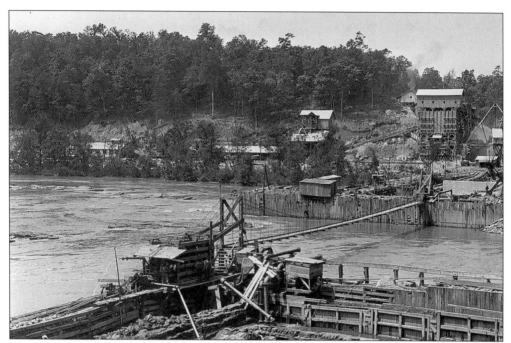

This photograph shows the interior of Mitchell Dam's second cofferdam (on the river's east bank) and the suspension bridge connecting the work site. The third cofferdam would be placed in the channel the bridge spans. (Courtesy of APCA.)

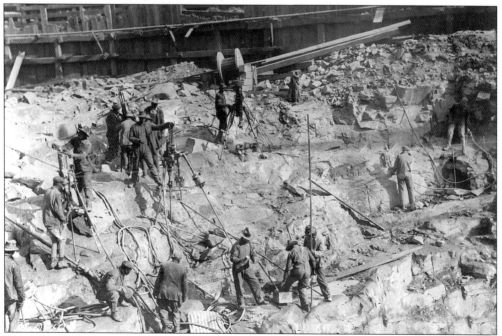

Workers drill holes in the bedrock for the placement of dynamite charges at Mitchell Dam—a necessary first step for the ensuing excavation work. This was, of course, a delicate operation, made even more so by the tons of water kept at bay by the cofferdams only feet away. (Courtesy of APCA.)

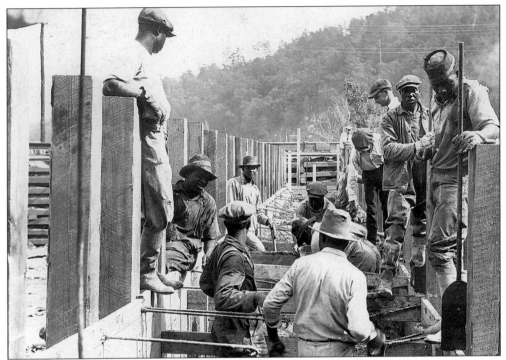

Workers pack cement at Mitchell Dam. Although living in the segregated work camps—a typical convention of Alabama at the time—African-American workers were reportedly well treated by APC. "Mitchell Dam will be sooner and better built for this model camp," reported Birmingham's *Age-Herald*, "because conditions there promote self-respect and bring to the fore the sense of decency which is in all, black, white, red, brown or yellow." (Courtesy of APCA.)

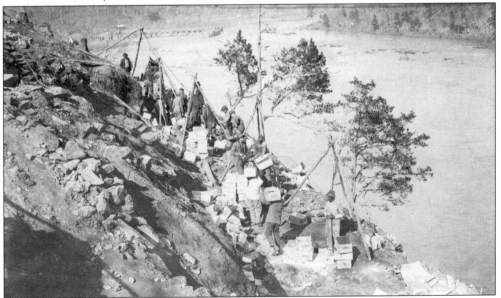

Off-site quarries supported the construction of Mitchell Dam. Here, workers prepare for a dynamite shot to blast rock loose. The dam's construction site can be seen in the background. (Courtesy of APCA.)

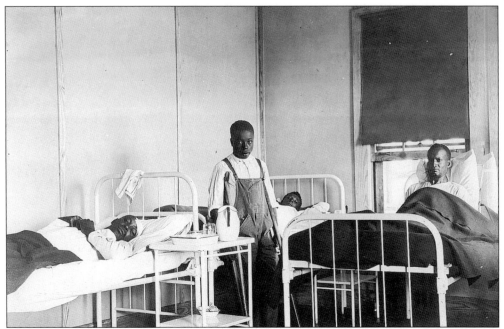

In order to tend to its workers and their families, APC constructed a fully staffed, 15-bed hospital at Camp Mitchell. Ailments ranged from malaria to typhoid to work injuries. (Courtesy of APCA.)

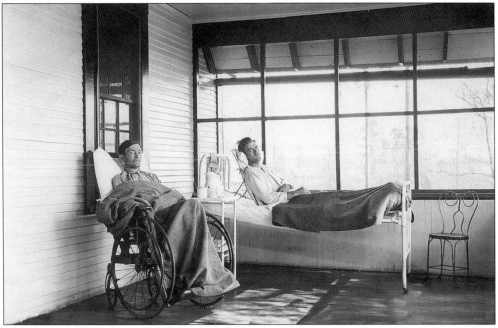

The dangerous nature of work during the construction of Mitchell Dam kept Dr. Samuel R. Benedict and his staff busy. In addition to supervising the health standards of the work camps, he and his staff tended to a string of injured and sick workers, such as the men shown here. Dr. Benedict's work peaked in June of 1922, with a total of 860 hospital visits to his wards. (Courtesy of APCA.)

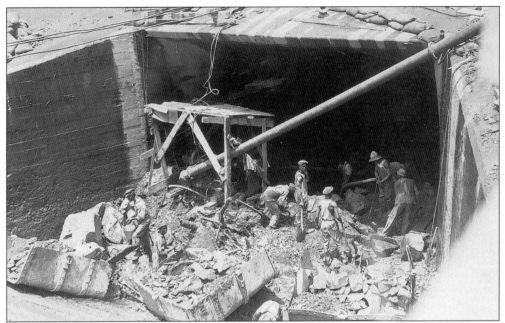

Workers labor to clear debris from the mouth of the east draft tunnel for Mitchell Dam's Unit No. 3. The water that would eventually flow through this tunnel would turn the water wheel located beneath the unit's turbine generator. (Courtesy of APCA.)

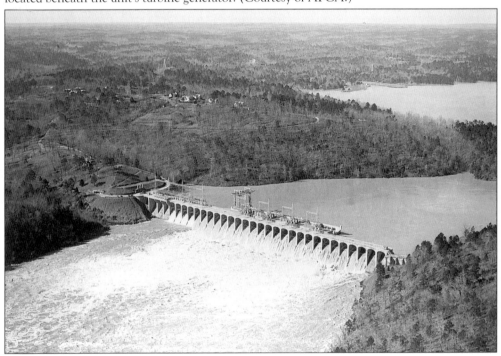

APC completed Mitchell Dam and put Units 1 through 3 into service on August 15, 1923. A fourth unit was added in 1949, and following the retirement of the first three units in 1985, three new units were added. Today, the modern dam's generators have a capacity of 170,000 kilowatts. (Courtesy of APCA.)

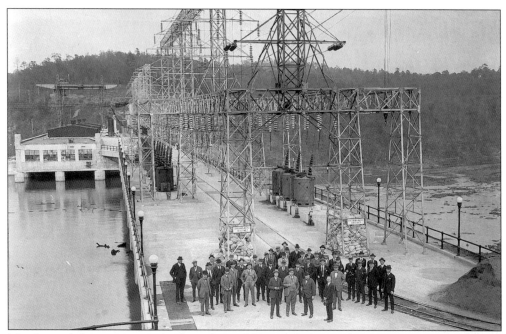

Members of the investment banking firm of Harris, Forbes and Company, accompanied by Thomas Martin, visited Mitchell Dam in 1923. A year later, Southeastern Power and Light was organized as an American holding company to take over the ownership of APC from Alabama Traction, Light and Power Company. (Courtesy of APCA.)

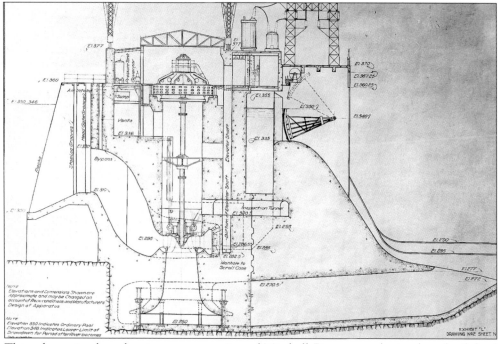

This schematic plan, showing a cross-section of Mitchell Dam, was submitted to the federal government in 1920 as part of Alabama Power Company's application for its hydropower license for the dam. (Courtesy of APCA.)

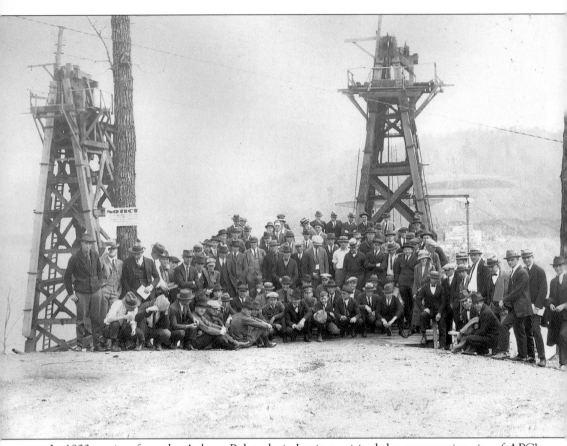

In 1923, seniors from the Auburn Polytechnic Institute visited the construction site of APC's third hydropower project, that would eventually be named after Thomas Martin, at Cherokee Bluffs on the Tallapoosa River. The female student in this photograph (twelfth from the right) is likely Maria Whitson, the first woman to graduate from an Alabama institution with a degree in electrical engineering and a future APC employee. (Courtesy of APCA.)

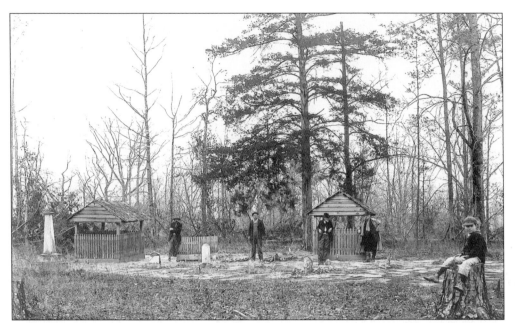

Part of the effort in the construction of Martin Dam was the relocation of those graves that would be inundated by the new reservoir. That job fell to Mr. E.J. Duncan, an Alexander City undertaker, who received $42 a grave, plus mileage, to exhume and re-inter the affected gravesites. Some relatives of the deceased, however, opted to simply leave the bodies of their loved ones in place. So they remain today, with graves out of sight beneath the placid waters of Lake Martin. (Courtesy of APCA.)

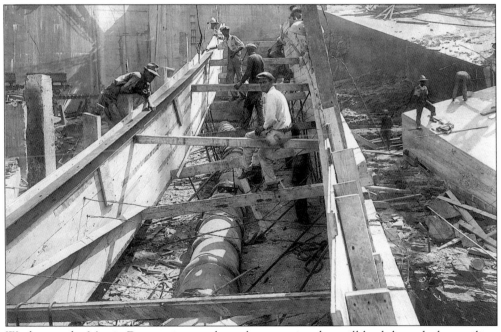

Workers at the Martin Dam project work on the vent pipe that will lead through the auxiliary dam. Construction of Martin Dam began in 1923 and was, like Mitchell Dam, handled by the Dixie Construction Company. (Courtesy of APCA.)

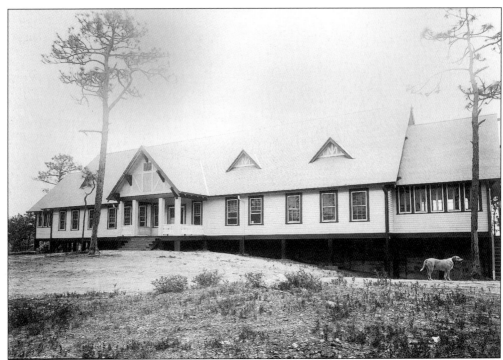

APC had learned the importance of having on-site medical care at the Martin Dam construction site during the construction of its earlier dams. Accordingly, it constructed the hospital shown in this photograph, where Dr. W.S. Whiteside tended to outbreaks of measles, mumps, smallpox and, of course, the inevitable workplace injuries. He later reported treating 75 "severe fractures" in the two years the hospital operated. (Courtesy of APCA.)

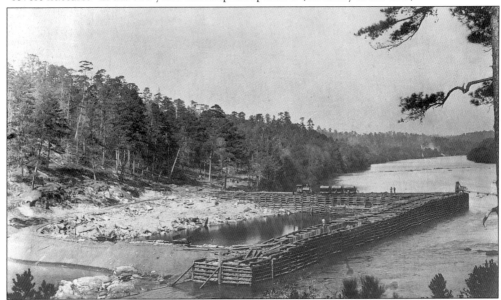

Just as with the previous construction of Lay Dam, building cofferdams such as the ones shown here on July 24, 1923, was an essential initial step in the construction of Martin Dam. (Courtesy of APCA.)

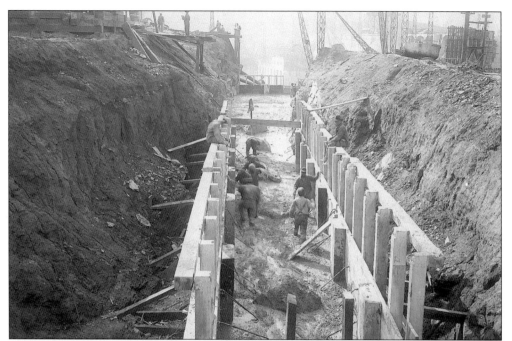

The men in this scene are working in the concrete of Martin Dam's core wall. According to historian Harvey Jackson, dam legend has it that a worker fell off a platform during the pouring of a deeper batch of concrete. Unable to be rescued in time, his body reportedly remains entombed in the dam's concrete to this day. (Courtesy of APCA.)

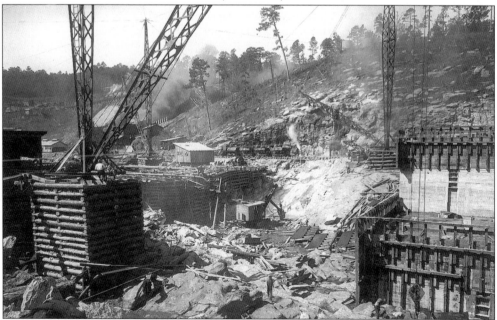

With the cofferdams in place, the Dixie Construction Company workers could begin to excavate the water wheel pits underneath what would eventually be the dam's powerhouse. This photograph shows such excavation work for what will be Units 2, 3, and 4. (Courtesy of APCA.)

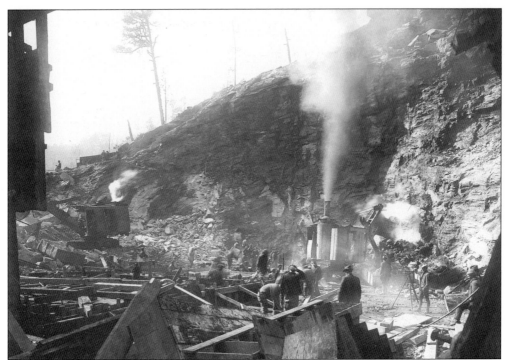

In dangerously close quarters, workers and steam shovels, under the guidance of surveyors and engineers, excavated the water wheel pits for Martin Dam's Units 1 and 2. (Courtesy of APCA.)

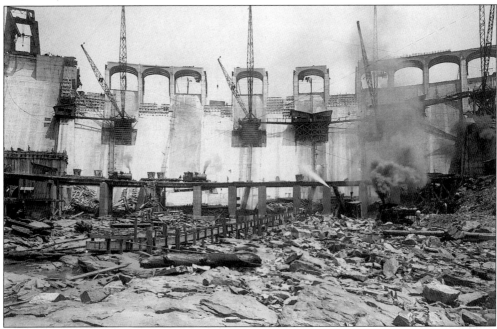

A critical part of managing the reservoir behind Martin Dam—for both power generation and flood control—was the dam's stream control gates, shown in this photograph under construction. (Courtesy of APCA.)

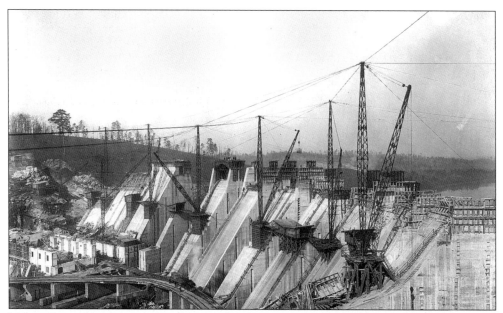

Martin Dam takes shape in this photograph. The fear that this dam would rob the downstream Mount Vernon-Woodberry Cotton Duck Company of water to power its mill had spawned a lawsuit that eventually reached the United States Supreme Court. There, Oliver Wendell Holmes sustained APC's position, endorsing Thomas Martin's endeavor to "gather the streams from waste." (Courtesy of APCA.)

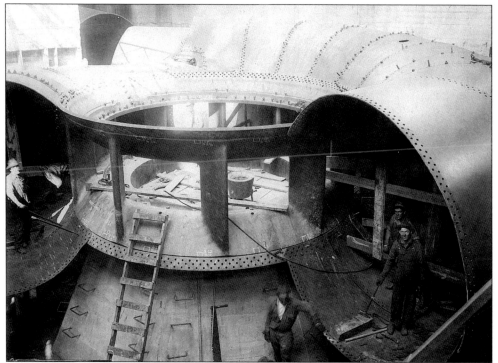

The workers shown here are fabricating the steel scroll case for Unit No. 2, which will guide the water through the unit's water wheel. (Courtesy of APCA.)

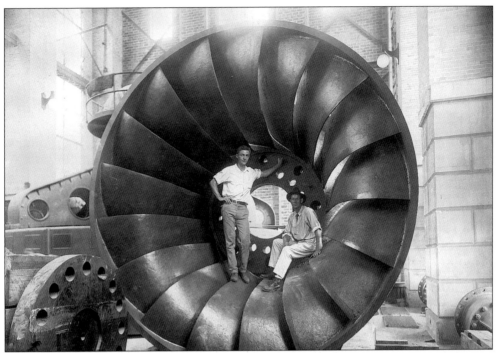

Two of the company's workers pose inside the water wheel soon to be installed for Martin Dam's Unit No. 1. (Courtesy of APCA.)

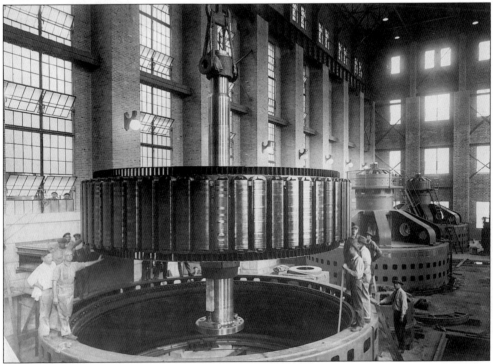

Inside of Martin Dam's powerhouse in 1926, workers prepare to lower the assembled rotor for Unit No. 2 into the generator housing. (Courtesy of APCA.)

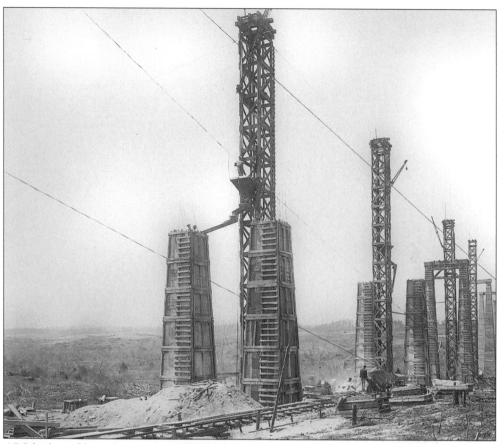

APC had to address the impact of the Martin Dam's reservoir on the surrounding towns. When locals refused to accept a ferry to replace the to-be flooded Alexander City–Tallassee road, APC agreed to build what would become known as the Kowaliga Creek Bridge. First pillars would be built and then, when the reservoir flooded, the connecting girders would be floated in by barge. (Courtesy of APCA.)

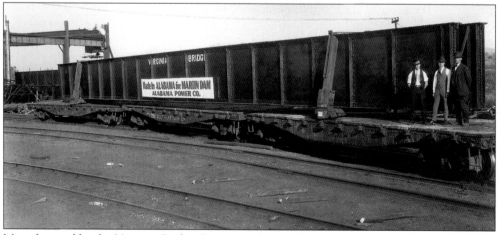

Manufactured by the Virginia Bridge Company, the steel girders for the Kowaliga Creek Bridge were then shipped via rail to Lake Martin in 1927. (Courtesy of APCA.)

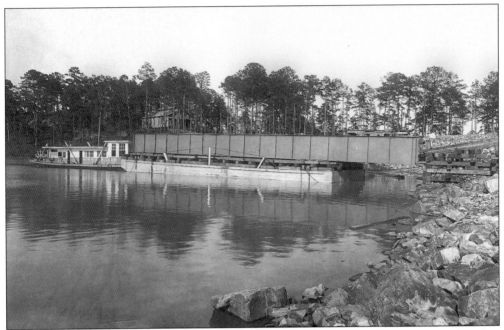

Once at the now-filled Lake Martin, the Kowaliga Creek Bridge girders were transferred to barges to be floated out to the skeletal bridge. Cranes would then lift them upon the waiting pillars. (Courtesy of APCA.)

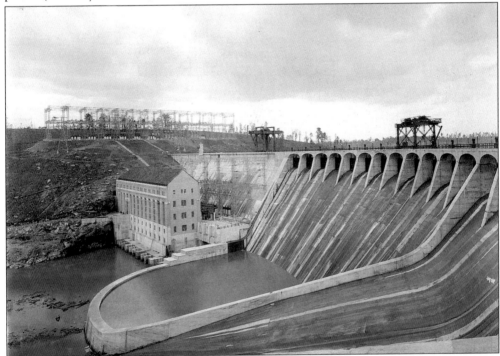

By the time Alabama Power Company brought the turbines of Martin Dam on line on December 31, 1926, the dam had impounded what was at the time the largest artificial body of water in the world—a lake of 40,000 acres with 700 miles of shoreline. (Courtesy of APCA.)

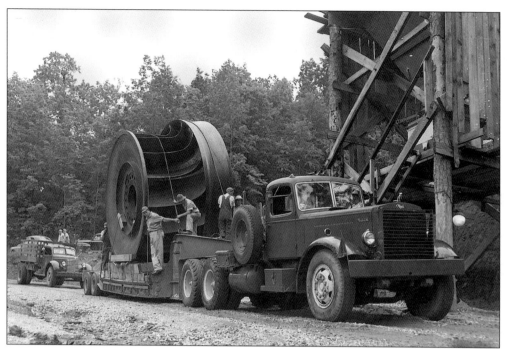

In 1952, APC added a fourth generating unit to Martin Dam. The water wheel for the new unit was delivered to the dam by heavy flatbed truck. (Courtesy of APCA.)

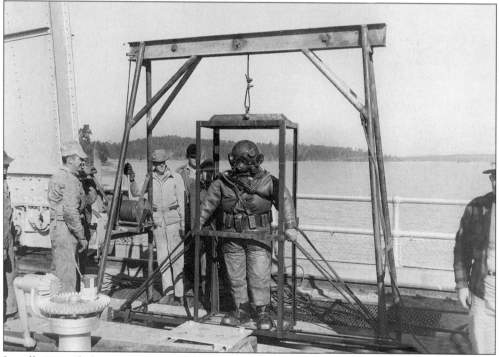

Installation of the new unit at Martin Dam required a careful inspection of the dam's headworks, as undertaken by divers such as the one shown in this photograph. (Courtesy of APCA.)

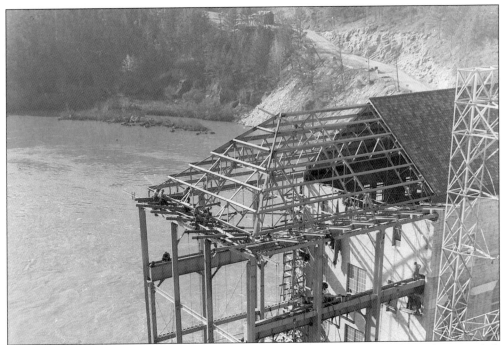

Naturally, the addition of another unit required that Martin Dam's powerhouse be extended. This photograph shows the necessary construction underway in 1952. (Courtesy of APCA.)

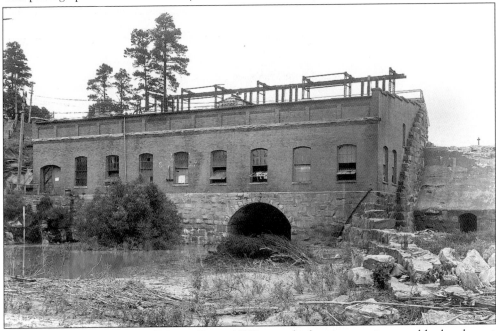

Following the construction of Martin Dam, APC's next hydropower project would take place at a site on the Tallapoosa known as "Upper Tallassee." This was a historic site in that it marked the location of Alabama's first hydroelectric facility, constructed in 1902 but later abandoned, as shown in this photograph. APC began construction of what would become Yates Dam on this site in 1927. (Courtesy of APCA.)

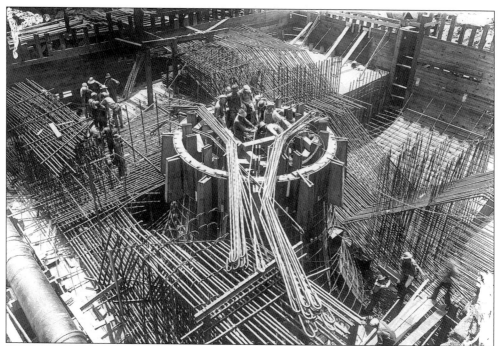

Workers in this photograph are weaving intricate strands of rebar to provide support for the concrete that will eventually encase Yates Dam's Unit No. 1. This dam was named after Eugene A. Yates, APC's first chief engineer who had overseen construction of Lay Dam 15 years earlier. (Courtesy of APCA.)

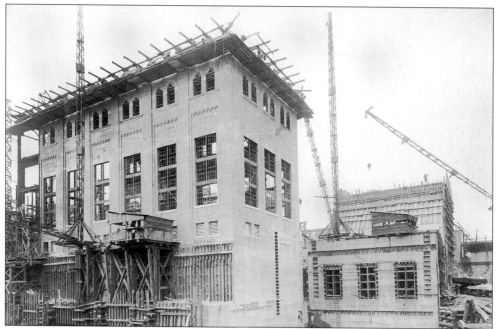

By October 31, 1927, the powerhouse at the Yates Dam and Hydroelectric Generating Plant was well under way. Once completed, it would contain two generating units with a capacity of 16,000 kilowatts each. (Courtesy of APCA.)

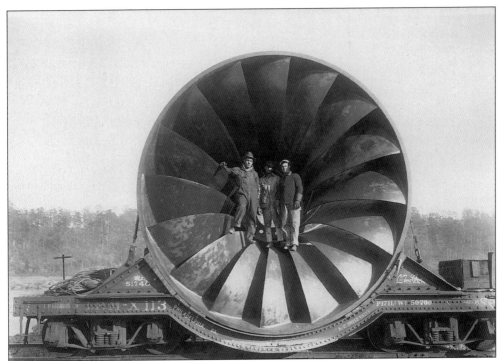

APC shipped Yates Dam's water wheels via flatbed railcar to the construction site in December of 1927. Each water wheel weighed 144,000 pounds and was designed to spin at 80 rotations per minute. (Courtesy of APCA.)

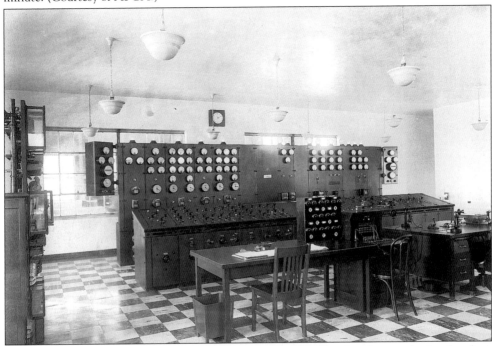

The control room at Yates Dam in 1928 was a simple affair by the standards of today's hydropower generation and dispatching systems. (Courtesy of APCA.)

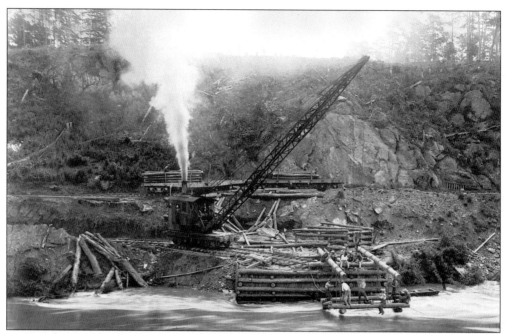

Even as APC was still completing Yates Dam, it was already beginning work on the Coosa River, on what would become Jordan Dam, near the town of Wetumpka. (Courtesy of APCA.)

As with APC's other construction projects of the era, a self-supporting company town blossomed by the Jordan Dam site to support the work crews. Shown here, in December of 1926, is the dam's commissary and water filter plant. (Courtesy of APCA.)

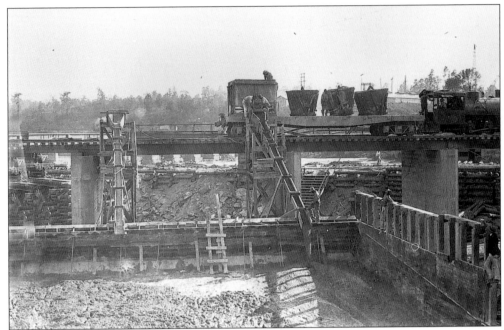

Steam engines brought in concrete to Jordan from the site's mixing plant. At the time, the construction of Jordan Dam was the largest power project undertaken by private capital in the South. It reportedly cost $12,275,010 when finally completed in 1988. (Courtesy of APCA.)

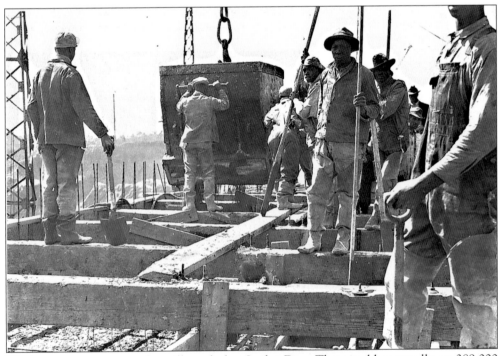

Workers pour concrete on the spillway deck at Jordan Dam. They would eventually use 389,000 cubic yards of concrete on the massive project. (Courtesy of APCA.)

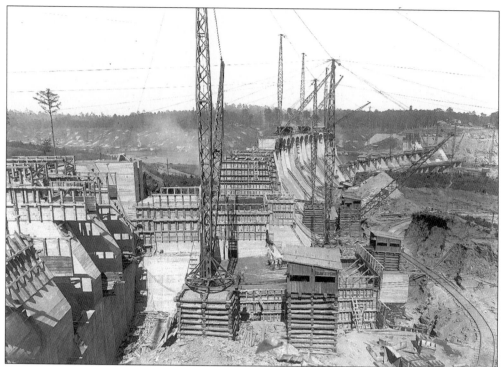

This photograph displays the general progress at Jordan Dam, looking east across the Coosa River, in October 1, 1927. When it came to naming the dam, APC wanted to honor two of its directors and financial backers, Sidney and Reuben Mitchell. APC already had a Mitchell Dam, however, and so the new dam was named after their mother, Elmira Jordan. (Courtesy of APCA.)

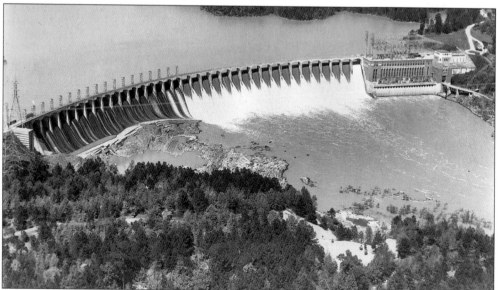

APC put Jordan Dam into service on December 31, 1928. Its four turbines possessed a generating capacity of 25,000 kilowatts each, and its walls held back a lake of 6,800 acres. (Courtesy of APCA.)

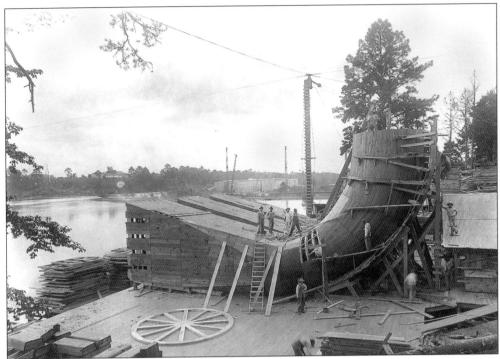

In April of 1928, the company began construction work at a location known as "Lower Tallassee," on the Tallapoosa River three miles downriver from Yates Dam. Shown in this photograph is one of the dam's draft tube concrete forms and the carpenters responsible for its creation. (Courtesy of APCA.)

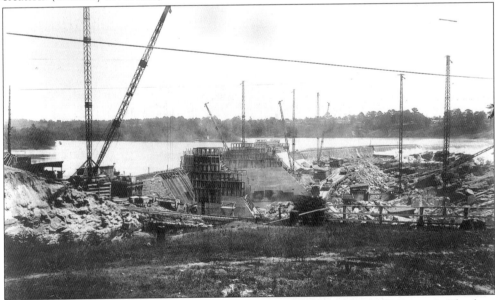

The dam at Lower Tallassee would eventually be named Thurlow Dam, after Oscar G. Thurlow. Thurlow's service to the company included duties as APC's design engineer for Lay Dam, construction manager for the Dixie Construction Company (1917–1923), chief engineer (1916–1930), and vice president (1924–1930). (Courtesy of APCA.)

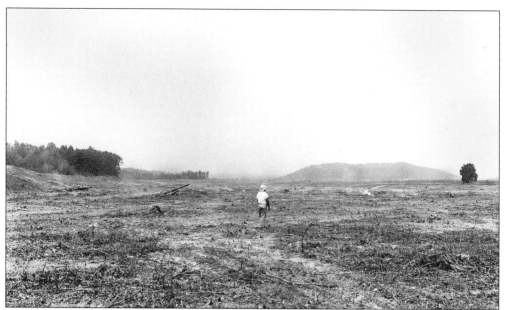

The Great Depression brought an end to APC's first round of ambitious hydropower projects on the Coosa and Tallapoosa Rivers. By 1959, however, APC set forth on another round of dam construction. Among the first was the construction of Weiss Dam, beginning in 1959 in the upper reaches of the Coosa River in Alabama. This photograph illustrates the magnitude of properly clearing what would eventually be the reservoir bed for the 30,200-acre lake. (Courtesy of APCA.)

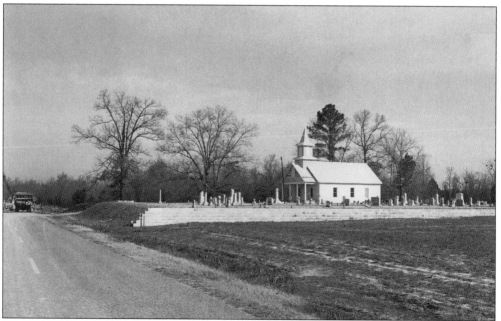

Among the activities necessary to the erection of Weiss Dam was the raising of nearby Calcedonia Cemetery by approximately four feet. Other activity took place much further off site, while APC's attorneys labored on Capitol Hill to secure the legislation necessary for federal approval of further hydropower development in the state. (Courtesy of APCA.)

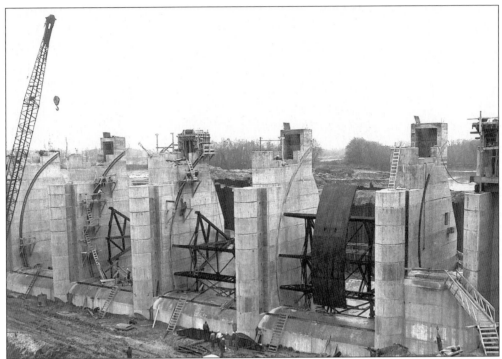

By January 5, 1960, work had progressed at Weiss to a point where the dam's spill gates were being installed. This dam was named after Fernand C. Weiss, APC's vice president for engineering and construction. (Courtesy of APCA.)

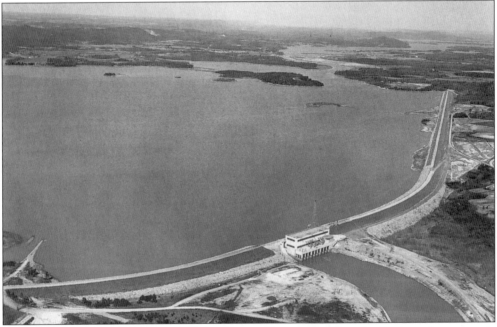

APC completed Weiss Dam and Hydroelectric Generating Plant in 1961, and a reservoir gathered from the drainage of a 5,273-square-mile watershed soon began filling behind it. (Courtesy of APCA.)

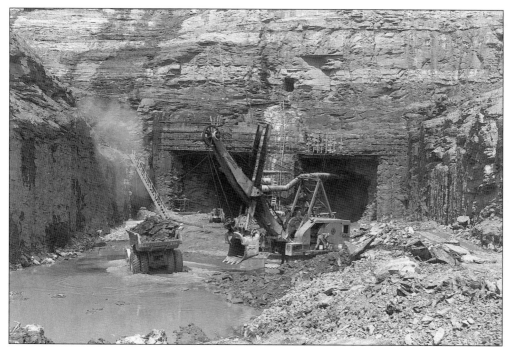

As APC sought to expand its generating capacity in the 1950s and 1960s, it looked beyond the Coosa and Tallapoosa Rivers for sources of hydropower. In 1958, APC began work on Lewis Smith Dam, which would be located on the Warrior River in the hill country northwest of Birmingham. The company's engineers decided to use geography to their advantage for this project. Here, shovels and dump trucks excavate what will be the powerhouse. The water-funneling tunnels punched through the hillside are visible to the rear. (Courtesy of APCA.)

Lewis Smith Dam would be a rockfill, rather than a concrete dam—one of the largest of its type in the world. Consequently, careful soil borings to ensure adequate soil density were essential. (Courtesy of APCA.)

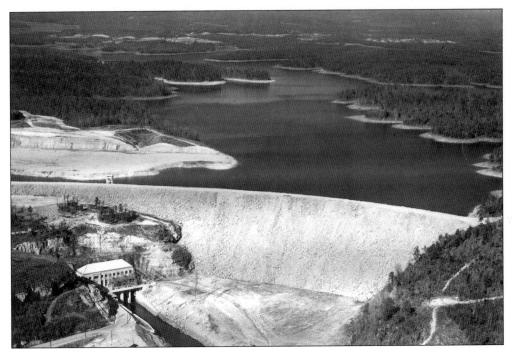

Once completed in 1961, Smith Dam stretched 2,200 feet long, stood 300 feet high, and impounded a scenic lake of 21,200 acres. It was named after Lewis Smith, who had served as APC's president from 1952 to 1957. (Courtesy of APCA.)

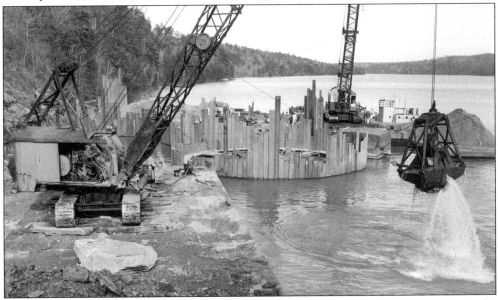

As work at Smith Dam drew to a close, engineers and surveyors were already starting on the next project on the Warrior River, the construction of a hydropower generating facility on the already existing John H. Bankhead Dam. Constructed in 1916 by the Corps of Engineers, Bankhead Dam was named after Sen. John Bankhead, the Alabama senator who, coincidentally, had been instrumental in the early 1900s in securing William Patrick Lay the approval for his proposed dam on the Coosa River. (Courtesy of APCA.)

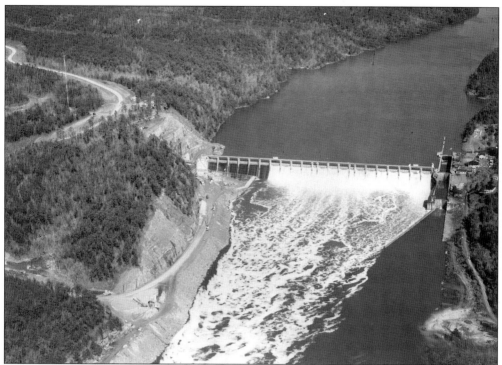

Once completed in 1963, the APC's Bankhead project still enabled the operation of the Corps' lock for river navigation, visible in this photograph on the right of the dam. Such a lock was necessary in order to enable the continuation of barge traffic on the Warrior River between Birmingport, which serviced Birmingham, and destinations downstream. (Courtesy of APCA.)

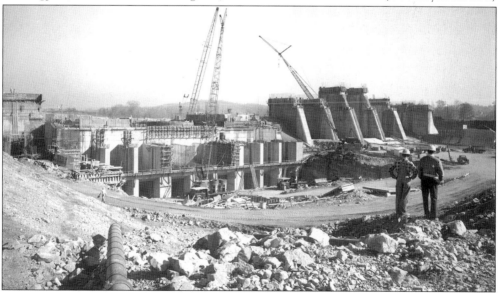

During the construction of Bankhead Dam, work was also progressing to the east on the Tallapoosa River. There, APC commenced work on what would eventually become Logan Martin Dam, named after APC's longtime general counsel and brother of Thomas Martin. (Courtesy of APCA.)

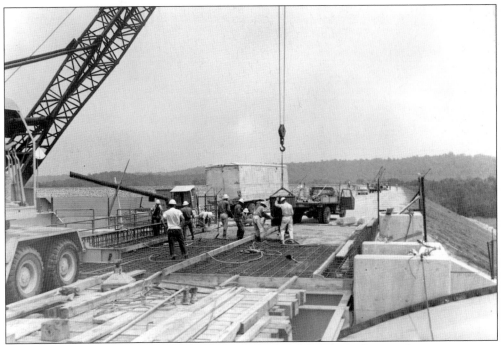

By July 23, 1964, work had progressed at Logan Martin to the point where workers were pouring concrete on the dam's spillway. The dam eventually went into service on August 10, 1964. (Courtesy of APCA.)

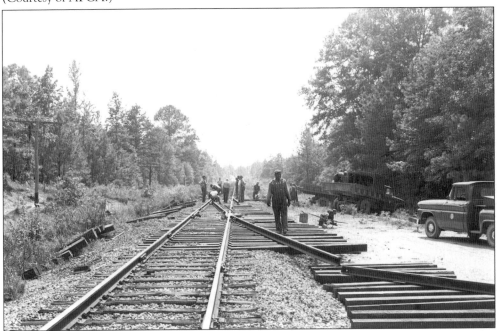

Concurrent with the work at Logan Martin, APC set forth building another dam on the Upper Coosa. Ancillary work on the project included the laying of new railroad tracks to the construction site of what would eventually be known as H. Neely Henry Dam. (Courtesy of APCA.)

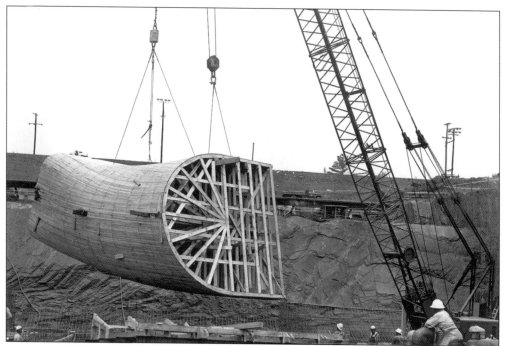

The construction and placement of the wooden concrete forms for the dam's draft tubes was just as important and delicate in 1964 at H. Neely Henry Dam as it had been at Lock 12—50 years earlier. (Courtesy of APCA.)

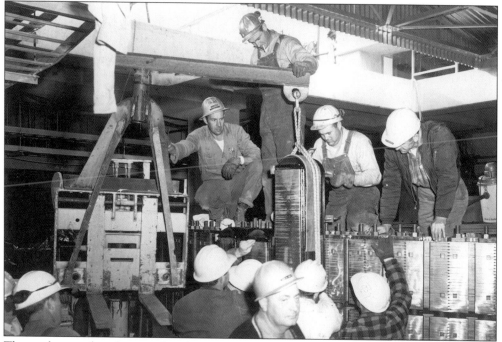

The workers in this photograph, taken in December of 1965, are setting the first rotor pole for Neely Henry Dam's Unit No. 1. APC placed the dam in service on June 2, 1966, and named it after APC's senior executive vice president. (Courtesy of APCA.)

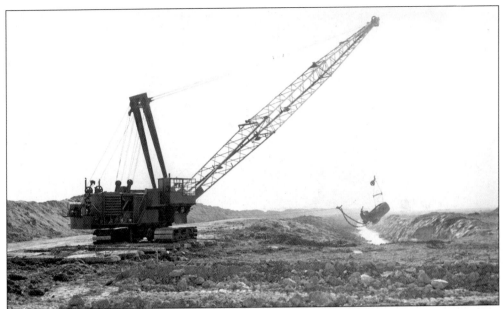

Another hydropower project progressed at the same time as the construction of Henry Dam when APC began work on Walter L. Bouldin Dam, destined to share a reservoir with Jordan Dam, in 1964. Modern power equipment supplanted the hundreds of laborers and mules needed for the earlier jobs, enabling such simultaneous construction activity at different dam sites. (Courtesy of APCA.)

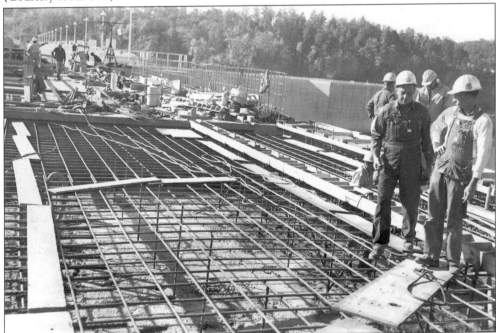

APC completed its development of the Warrior River system with the construction of Holt Hydroelectric Generating Plant, shown here in 1967 as workers prepare to pour concrete on its deck. APC built this plant on the heels of the Corps' completion of the dam itself a year earlier. (Courtesy of APCA.)

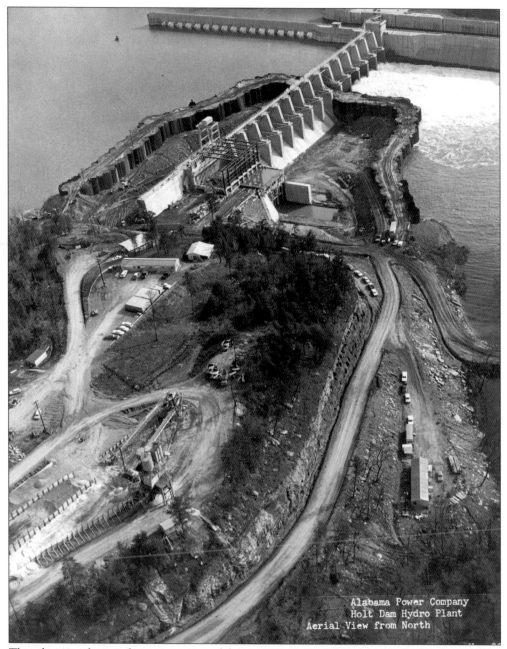

Alabama Power Company
Holt Dam Hydro Plant
Aerial View from North

This photograph provides an overview of the construction at Holt in January of 1968. Note the massive cofferdam protecting the construction of the powerhouse area, while the U.S. Army Corps of Engineers navigation lock continues to enable barge traffic on the Warrior River. (Courtesy of APCA.)

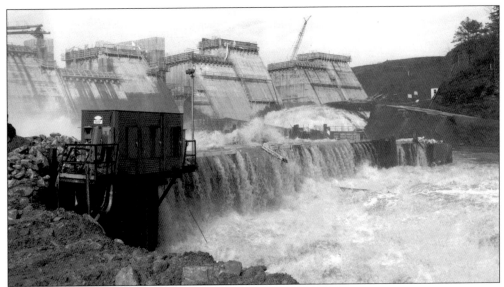

APC undertook what would be its last hydropower project to date when it commenced construction on what would become R.L. Harris Dam and Hydroelectric Generating Plant, on the upper Tallapoosa River near Wedowee. Unusually heavy winter floods in February of 1982 plagued the dam's construction. (Courtesy of APCA.)

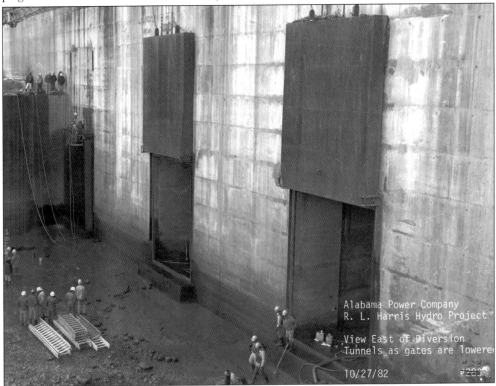

On October 27, 1982, APC lowered the gates at the R.L. Harris Dam. Placed into service on April 20, 1983, the dam's turbines were soon generating electricity from the water released from the dam's 10,660-acre reservoir. (Courtesy of APCA.)

Three

FOSSIL POWER

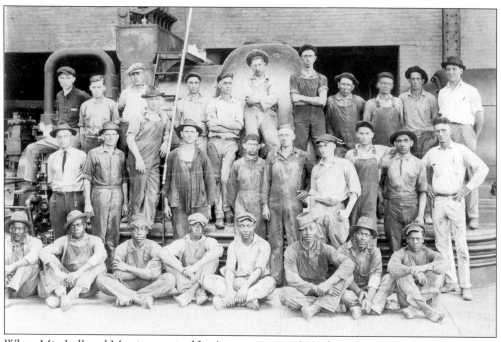

When Mitchell and Martin acquired Lay's company in 1912, they also acquired his rights to an unfinished coal-fired steam plant in the small city of Gadsden, on the banks of the Coosa River. By 1920, men such as these were responsible for the operation of APC's Gadsden Reserve Steam Plant. (Courtesy of APCA.)

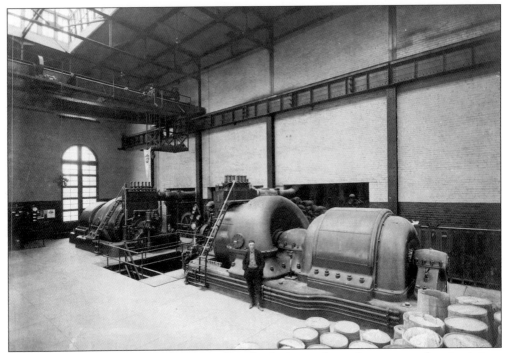

The Gadsden Reserve Steam Plant burned coal, which superheated water, transforming it into the steam that turned the electricity-producing turbines within the two generators shown here. (Courtesy of APCA.)

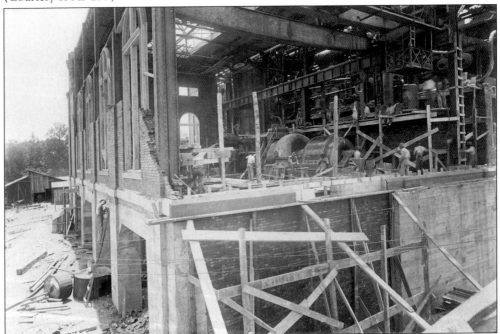

This photograph shows the Gadsden Steam Plant under construction. When completed, it would be capable of generating 10 megawatts of electricity—slightly over one percent of what APC's most powerful units generate today. (Courtesy of APCA.)

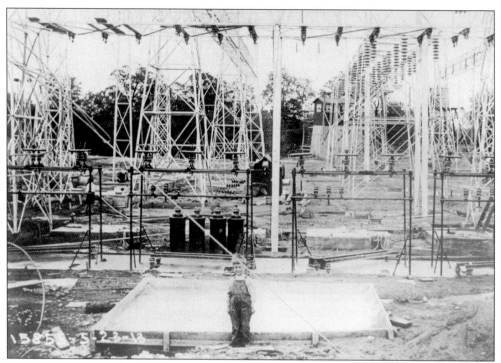

Power without the means to step it down to manageable voltages and transmit it to waiting customers would have been pointless, hence, the need for transformer yards, such as Gadsden's shown here under construction in 1913. (Courtesy of APCA.)

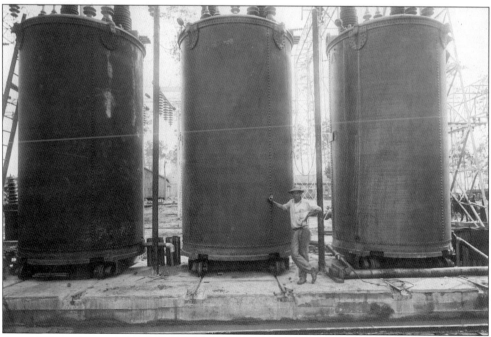

An APC worker poses besides Gadsden Steam Plant's massive transformers. (Courtesy of APCA.)

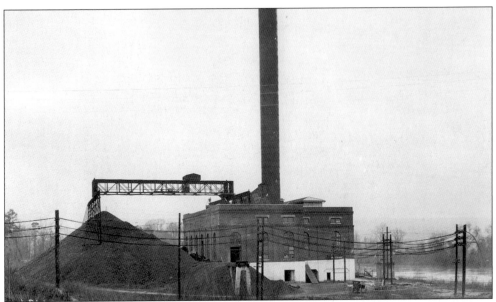

The finished Gadsden Steam Plant, shown in 1920, with the Coosa River to its right and its coal-storage pile to the left. (Courtesy of APCA.)

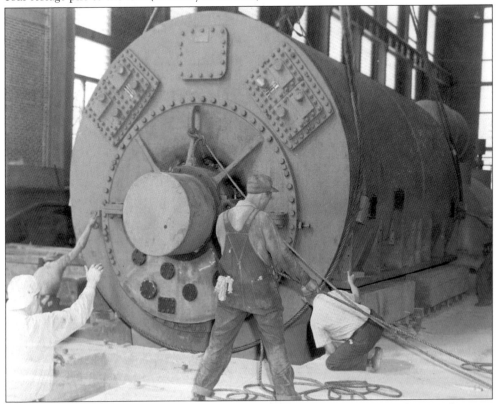

In 1949, APC built a new power plant at Gadsden to replace its obsolete predecessor. Here, workers install a 60,000-kilowatt Westinghouse generator in the new plant. (Courtesy of APCA.)

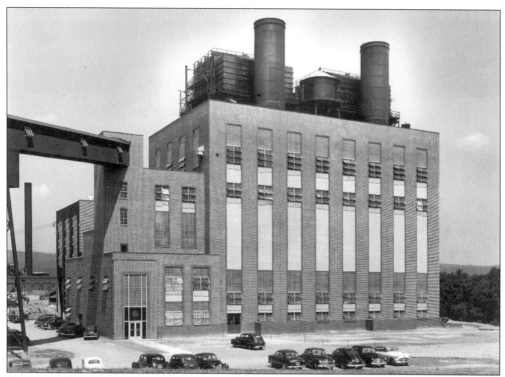

By September of 1949, APC had completed the new Gadsden plant. The old plant, not yet demolished, can be seen to the left rear of the new facility. (Courtesy of APCA.)

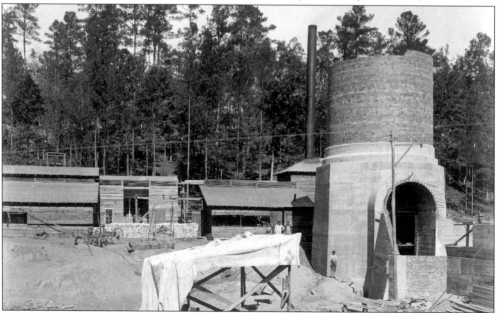

In 1916, the company began construction on what was initially known as the Warrior Reserve Steam Plant. The decision to locate it amid Walker County's abundant coal mines and astride the free-flowing Warrior River bespoke two needs of a steam plant—coal for fuel and water for steam. (Courtesy of APCA.)

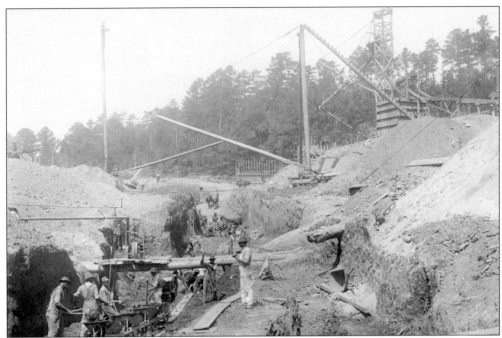

The excavation of large canals was necessary in order to enable the plant to obtain the water required for the generation of steam through the combustion of coal. A coal-fired plant like Warrior Reserve would provide APC with an ability to meet the state's growing demand for electricity, even during the low-water months of Alabama's hot summers—hence the name "Reserve." (Courtesy of APCA.)

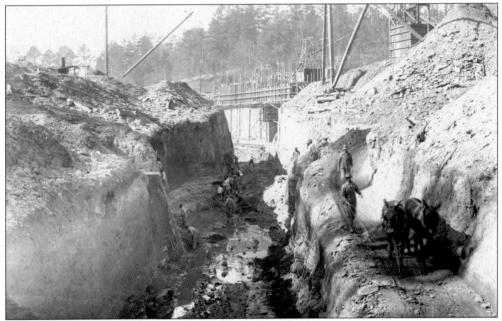

Just as mule power had been important in the construction of Lay Dam four years earlier, so it was in the construction of the Warrior Reserve Steam Plant. Here, mules assist in the excavation of the water intake canal. (Courtesy of APCA.)

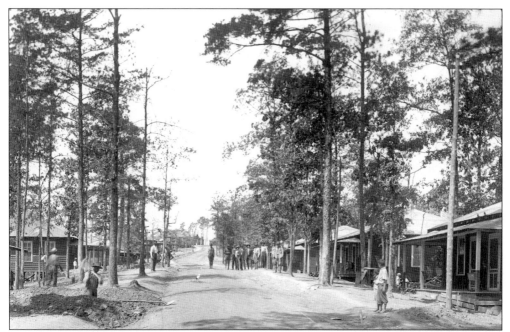

Residents at Warrior Reserve were first the construction workers and their families and then later the plant workers, the miners who kept the plant's furnaces supplied with coal, and the families of each group. This photograph shows company housing at the plant in 1918. Workers lived rent-free until the 1930s, when they began paying $4 a month per each of their home's rooms. (Courtesy of APCA.)

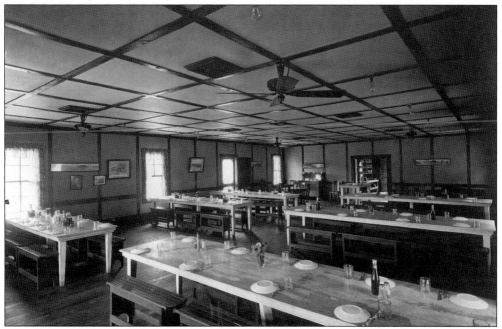

In addition to this dining hall, shown in 1922, Warrior Reserve Steam Plant and the surrounding company town eventually boasted a school, post office, commissary, bus station, ball field, and churches. (Courtesy of APCA.)

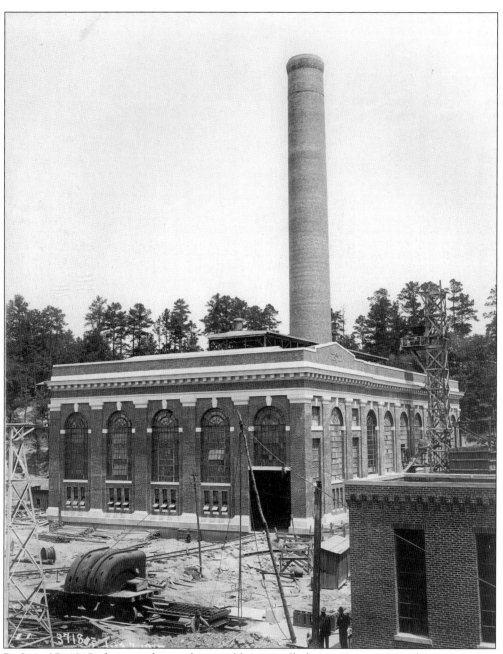

By June 27, 1917, the powerhouse that would eventually house Units 1, 2, and 3 was nearing completion. Its 3 turbines were supported by 18 sterling boilers, operating a pressure of 200 pounds per square inch of steam (compared to 3,500 psi at the plant's most modern unit today) and lit by hand. (Courtesy of APCA.)

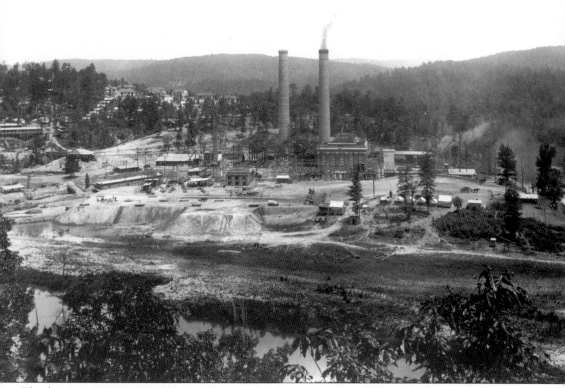

The first generating unit at Warrior Reserve went into service in 1917, just as the United States entered World War I. The second unit was completed in 1918, when this photograph was taken, at the federal government's expense in order to provide power to the government's nitrate plant in Muscle Shoals, 90 miles to the north. APC bought the unit in 1923, and added a third unit in 1924. (Courtesy of APCA.)

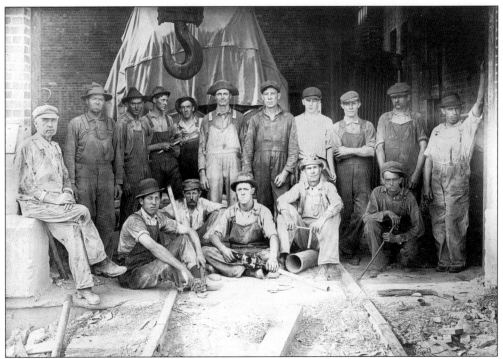

Workers such as the men in this photograph, taken in 1917, hand lit the Warrior Reserve Steam Plant's boilers and manually reamed the plant's huge banks of condenser piping to clean them of mud and other debris sucked in with the water from the Warrior River. (Courtesy of APCA.)

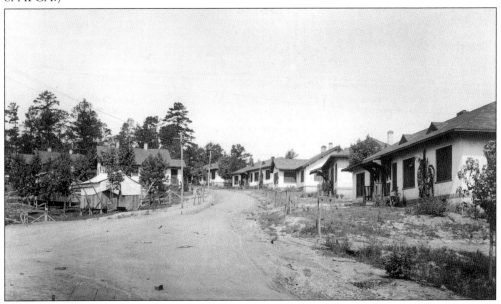

Hundreds of company homes dotted the hills surrounding the Warrior Reserve Steam Plant. It was an isolated community, separated from nearby towns by miles of muddy roads, and the plant superintendent served as the de facto town mayor and justice of the peace in addition to his duties within the plant itself. (Courtesy of APCA.)

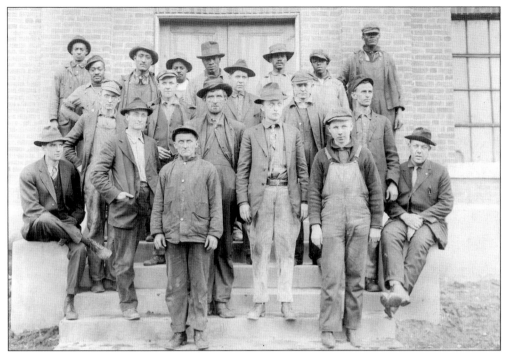

A group of workers at Warrior Reserve Steam Plant pose proudly in front of the plant's powerhouse in February of 1917. (Courtesy of APCA.)

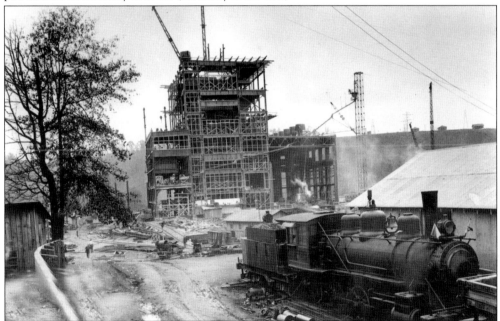

In 1924, with the construction of the plant's third unit, APC renamed Warrior Reserve Steam Plant after William Crawford Gorgas, the Alabama-born surgeon general who had provided APC with the star testimony necessary to defeat the hundreds of "mosquito lawsuits" challenging its hydropower projects. In 1928, APC began constructing a second powerhouse at the site, shown here under construction. (Courtesy of APCA.)

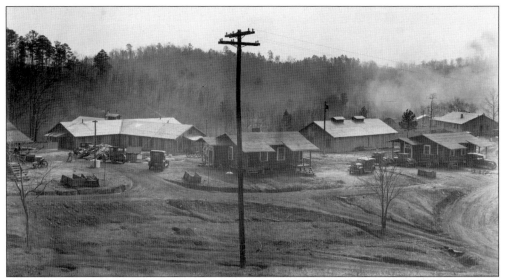

More construction at Gorgas meant more men to feed, which necessitated the construction of another mess hall and commissary for the construction workers. (Courtesy of APCA.)

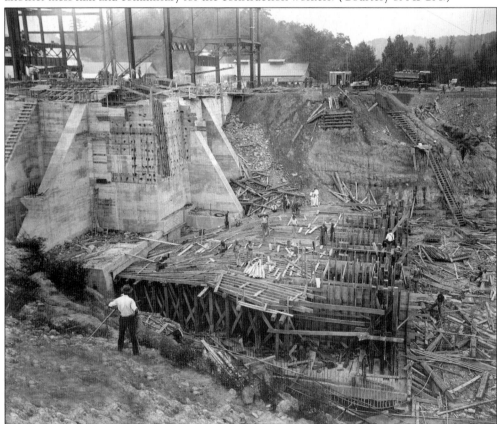

In this photograph, an engineer supervises the construction of Gorgas's second plant's water intake tunnel. The generating unit installed in this plant, unlike its predecessors, would make use of recycled water and pulverized coal. (Courtesy of APCA.)

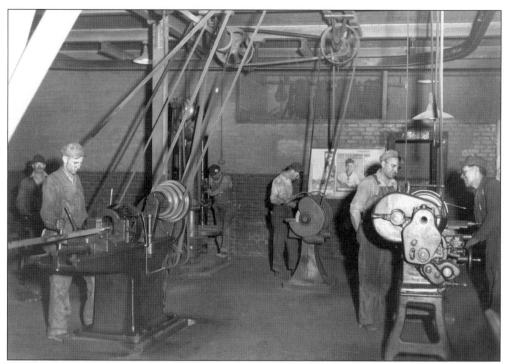

Company employees work in Gorgas's machine shop. On the far right are Cecil Ferguson and John Swanger. (Courtesy of APCA.)

In this photograph, workers erect the supports for Gorgas Unit 5's saturated rear wall header. Unit 5 came on line in 1944, boasting a hydrogen-cooled generator and a steam pressure of 900 pounds per square inch in its boiler. (Courtesy of APCA.)

Individuals such as these men, members of Gorgas's boiler maintenance crew, were in the front lines of the daily battle to ensure that the boilers were operating smoothly. When Gorgas's first units came on line in 1916 and 1917, the plant shut the boilers down on weekends for cleaning. These workers did not have that luxury. (Courtesy of APCA.)

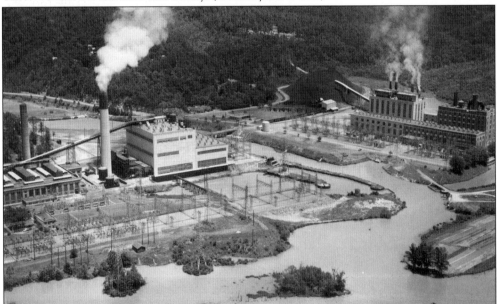

This photograph shows Gorgas Steam Plant *c.* 1968. The old 1917 plant (Gorgas Plant No. 1) is on the left, with Gorgas Plant No. 2 on the right and the newest plant (No. 3) in the center between them. Plant No. 1 would eventually be demolished to make room for the addition of coal-handling facilities for Gorgas's tenth generating unit, which came on line in 1972. (Courtesy of APCA.)

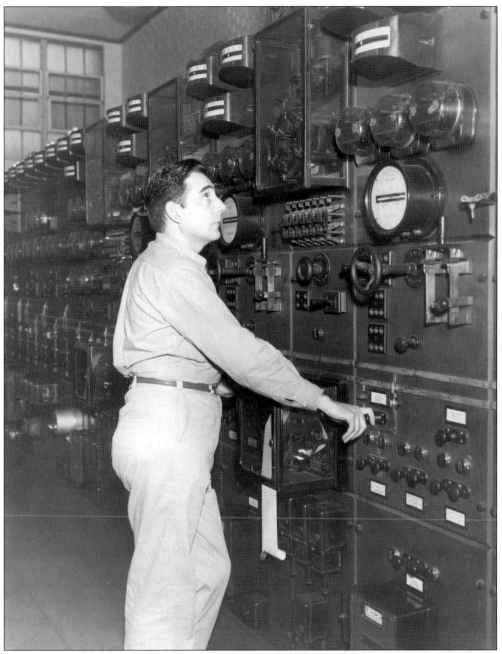

A worker carefully operates the controls of Gorgas Unit 3. A proper mix of air and coal was essential in order to achieve the most efficient combustion in the unit's boilers. Among the innovations explored at Gorgas was the company's experimentation with power from coal gasification in 1947. (Courtesy of APCA.)

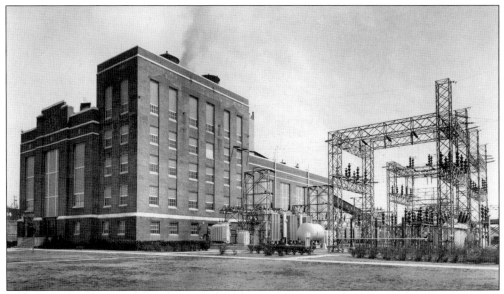

Coal was not the only fossil fuel utilized by APC. Its Chickasaw plant outside of Mobile, shown here, also relied upon oil and gas to produce its electricity-generating steam. Later, in 1970, APC began to pursue other means of electricity generation when it started construction of its Farley Nuclear Plant outside of Dothan. (Courtesy of APCA.)

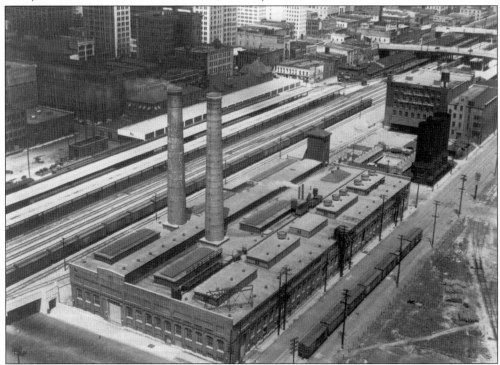

Originally, the Powell Avenue Steam Plant, owned by Birmingham Electric Company, was a competitor to Alabama Power Company in the Birmingham market. Birmingham's Louisville & Nashville rail yard and the city's skyline are visible to the northwest of the plant. APC acquired Birmingham Electric in 1952. (Courtesy of APCA.)

84

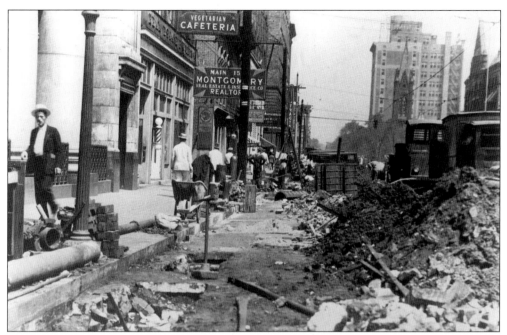

The challenges put forth in servicing downtown Birmingham from the Powell Avenue Steam Plant are evident in this photograph, which shows the messy result of line-laying construction from the plant along Twenty-first Street North. (Courtesy of APCA.)

Small trolley dump cars such as this were used to move coal from the Powell Avenue Steam Plant's coal pile to the waiting boilers. Rather than use the plant's steam for electricity generation, it was sent through wood-insulated pipes to nearby businesses and hospitals to provide heat in the winter. (Courtesy of APCA.)

In 1927, disaster struck at the Powell Avenue Steam Plant, when one of the plant's smokestacks toppled over onto the plant. (Courtesy of APCA.)

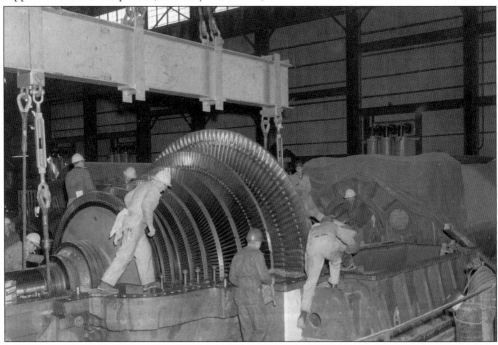

Workers in this photograph, taken December 21, 1959, install the low-pressure turbine rotor on Unit 1 at the Ernest C. Gaston Combustion Turbine Plant. Plant Gaston was named after one of the Southern Company's foremost engineers and the president of the Southern Electric Generating Company as well as Southern Company Services. (Courtesy of APCA.)

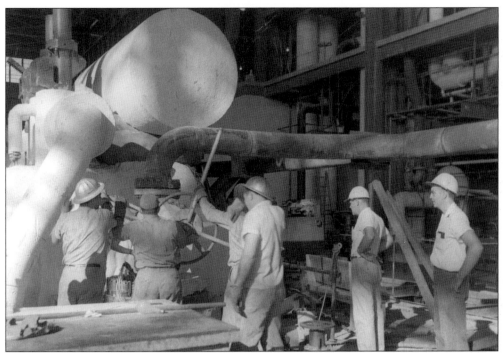

On May 25, 1960, workers started the main steam blow at Plant Gaston's Unit 2. The 1950s and 1960s were a time of great expansion for APC. Beginning with the construction of the Barry Steam Plant outside of Mobile in the early 1950s, APC followed that project with the construction of Plant Gaston and with further development of hydropower projects on the Coosa and Warrior Rivers. (Courtesy of APCA.)

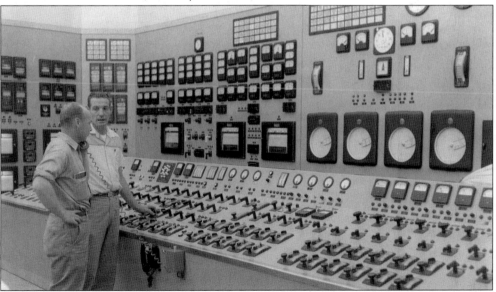

The Plant Gaston control room, shown here in 1960, represented the latest in coal-fired steam generation control technology at the time. The plant itself was a joint venture between Alabama Power and Georgia Power, under the auspices of the Southern Electric Generating Company. (Courtesy of APCA.)

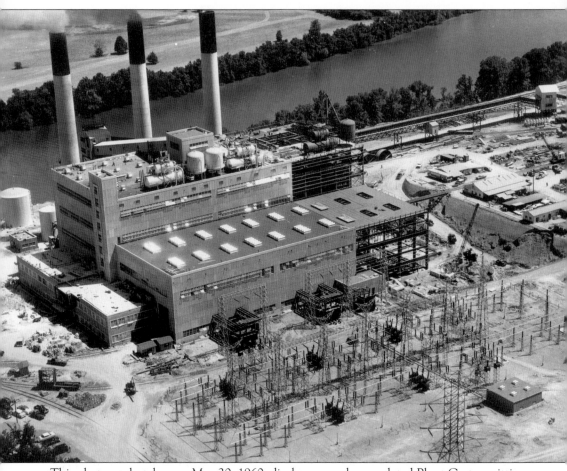

This photograph, taken on May 20, 1960, displays a nearly completed Plant Gaston, sitting on the banks of the Coosa River near Wilsonville. At the time, only the first of its four generating units had been brought into service. These units were owned jointly by APC and Georgia Power Company, one of APC's sister operating companies in the company's parent Southern Company. Today, Plant Gaston harbors five units with a combined generating capacity of 1,850 megawatts. (Courtesy of APCA.)

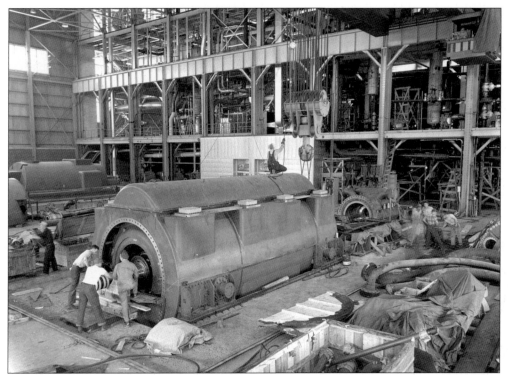

APC's Barry Steam Plant was named after James M. Barry, who served as APC's president from 1949 until 1952. In this photograph, taken April 1, 1954, work progresses on the turbine generator for the plant's Unit 2. (Courtesy of APCA.)

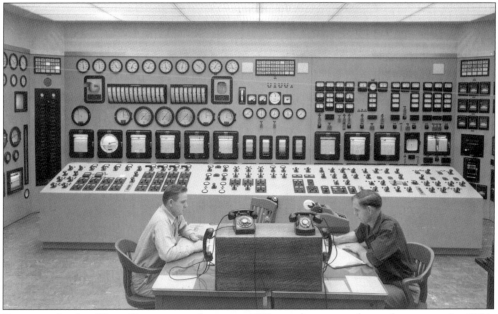

From inside the Plant Barry control room, APC employees, such as these men in 1954, managed the combustion of coal, the generation of steam, the creation of electricity, and its dispatch to distant customers, businesses, industries, and homes. (Courtesy of APCA.)

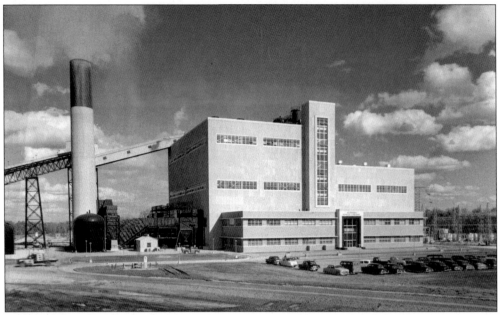

By November of 1954, the coal burned at Barry Steam Plant provided the energy to turn the two 125-megawatt turbine generators located at the plant at the time. (Courtesy of APCA.)

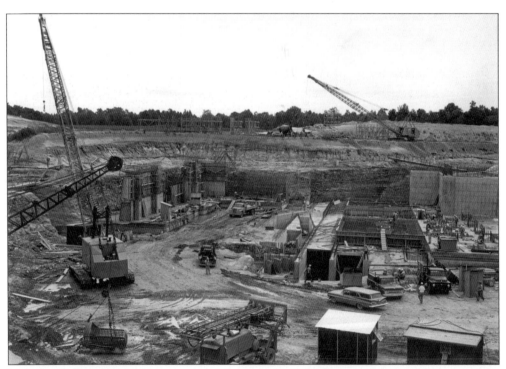

In 1962, Alabama Power began construction in western Alabama on what would become the Greene County Steam Plant. This photograph, taken on July 26, 1963, shows the progress of excavation work for what would eventually be the plant's powerhouse's foundation. (Courtesy of APCA.)

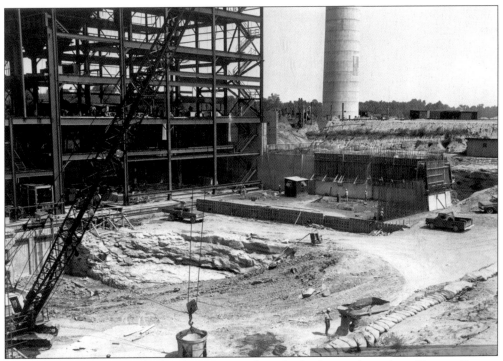

With the plant's first stack already constructed in the background, work at Greene County progressed with construction of the plant's boiler room. This plant would eventually boast two 250-megawatt turbine generators. (Courtesy of APCA.)

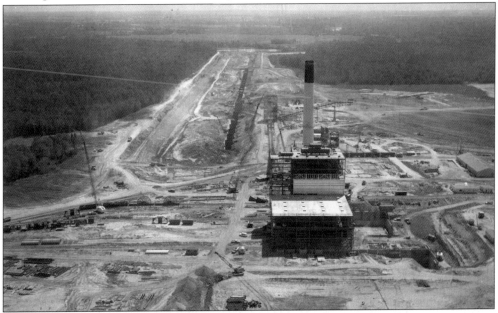

This aerial view of construction work at Greene County Steam Plant, taken September 8, 1964, displays the magnitude of the construction project—both within and beyond the actual powerhouse and boiler room structure. Once completed, the plant would be the largest employer in the area. (Courtesy of APCA.)

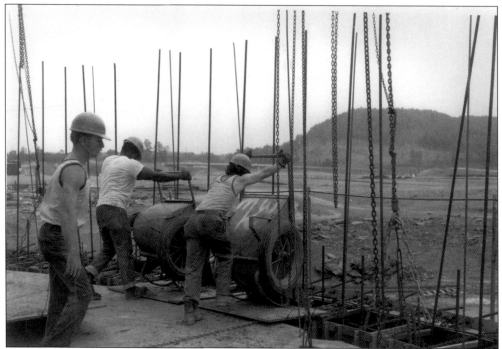

In the 1970s, APC embarked upon its last coal-fired steam plant construction project to date—the construction of what was initially known as West Jefferson Steam Plant. The name was soon changed to honor James H. Miller Jr., one of the company's senior vice presidents and an eventual president of Georgia Power Company. (Courtesy of APCA.)

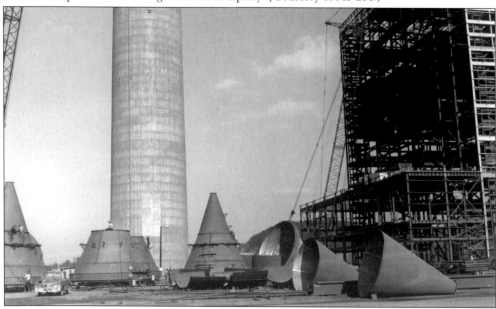

This November 1975 photograph shows the Miller construction site's coal silo fabrication yard. Populist animosity against APC in the 1960s and 1970s, coupled with the latter decade's inflation and poor economy, created significant construction delays for APC as it strove to complete the plant. (Courtesy of APCA.)

Four

POWERING THE HEART OF DIXIE

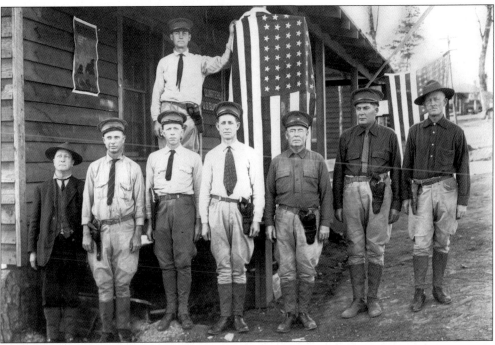

In World War I, when the federal government constructed Gorgas Unit 2 to power its Muscle Shoals nitrate plant, it stationed federal marshals at Gorgas. At the outbreak of hostilities, APC had patriotically transferred its rights to Muscle Shoals to the government for a token one dollar. Washington refused to return the promising site at the end of the war, however, eventually making Muscle Shoals a key part of its Tennessee Valley Authority development. (Courtesy of APCA.)

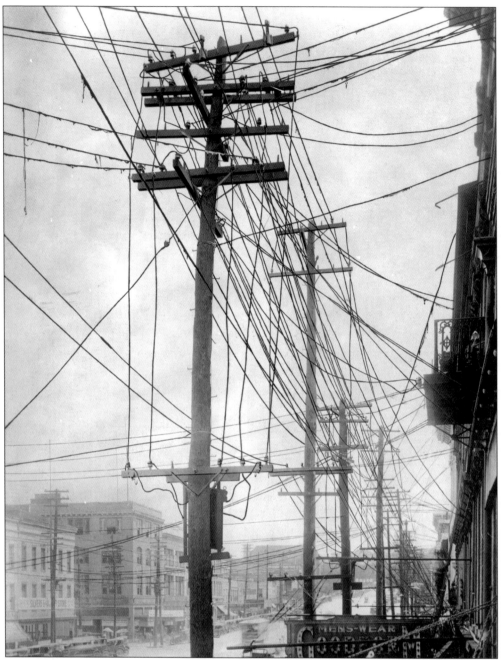

Electricity had first come to the Alabama capital of Montgomery in 1883, when a small dynamo lit 31 electric street lamps. By 1923, at the time this photograph was taken, the demand for electricity had grown tremendously, as the multitude of wires visible on this downtown street illustrates. (Courtesy of APCA.)

VOL. I. APRIL, 1920 NO. 1

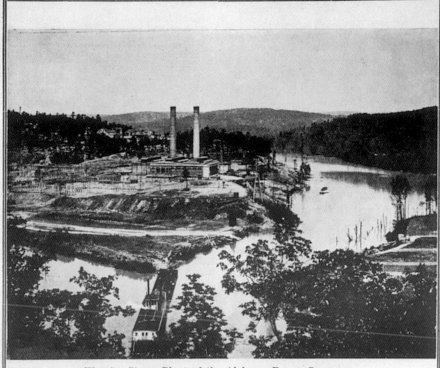

Warrior Steam Plant of the Alabama Power Company.

PUBLISHED MONTHLY BY THE

ALABAMA POWER COMPANY

BIRMINGHAM, ALA.

In April of 1920, APC published its first issue of *Powergrams*, still in print today. Thomas Martin, realizing that "the success of the Company must in the end depend upon its relations with the public," explained that the purpose of the monthly bulletin was to give employees "a picture . . . of our problems, our hopes and purposes." A photograph of Plant Gorgas graced the first issue's front cover, and the stories inside ranged from "Accident Instruction to Foremen and Employees," penned by the company's surgeon, to a social column entitled "Everybody's Affairs—Little Stories of Our Own Folks." (Courtesy of APCA.)

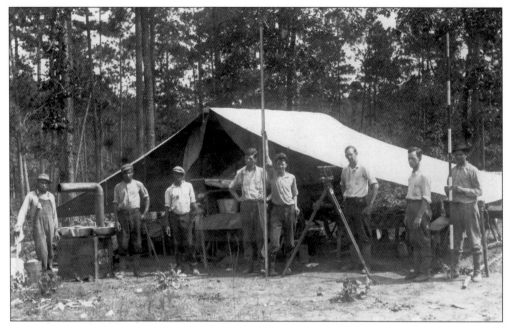

Survey crews, such as the group of men shown in this photograph taken in 1916, were responsible for mapping out the routes that would connect APC's dams and steam plants with their waiting customers. The crew's beds and dining table are in the tent behind them. (Courtesy of APCA.)

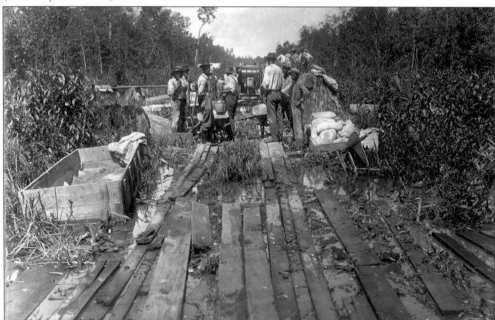

In 1927, APC became a truly statewide company when it acquired the Gulf Electric Company in Mobile and the Houston Power Company in southeast Alabama. The swamps of southern Alabama, however, posed a challenge when it came to laying transmission lines, as the men pouring concrete for a transmission tower in this photograph no doubt knew first hand. (Courtesy of APCA.)

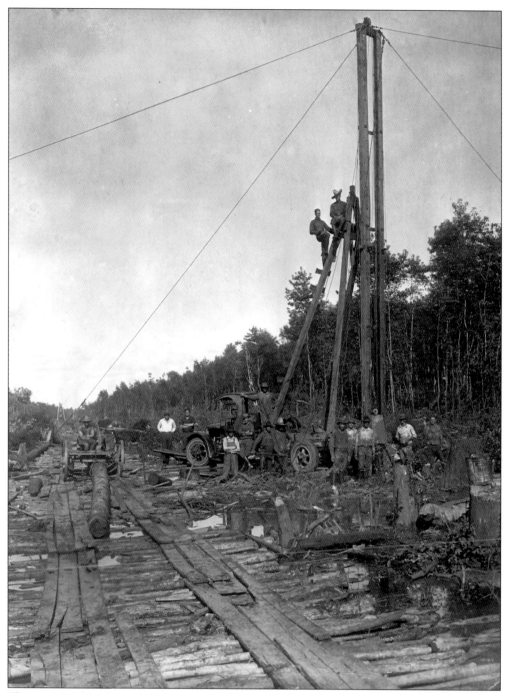

The men in this photograph, taken in 1926, are stringing transmission lines in the swampy terrain between Flomaton and Mobile. Today, helicopters would likely be used to place transmission towers in such difficult terrain. (Courtesy of APCA.)

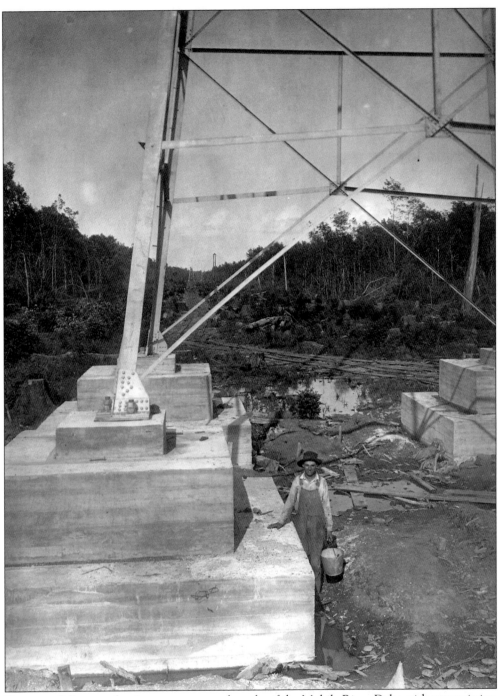

To successfully cross the rivers, swamps, and creeks of the Mobile River Delta with transmission lines, APC had to construct eight massive towers upon which to string the lines. In this photograph, a concrete worker poses beside his handicraft. (Courtesy of APCA.)

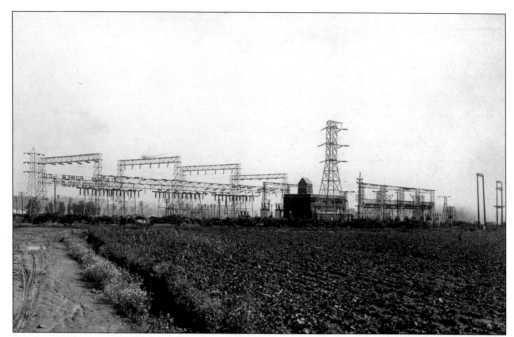

By the 1930s, transmission stations such as this one outside of Anniston were looming over Alabama farmers' fields that before had only sported cotton or soybeans. By 1935, APC boasted 4,000 miles of transmission lines routed through stations such as this one. (Courtesy of APCA.)

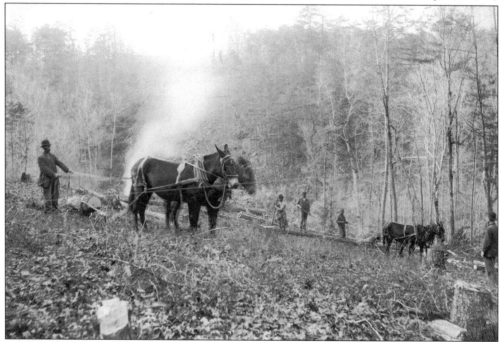

Just as mules had provided labor at the construction sites for the early dams and steam plants, so they contributed to the clearing of the right-of-ways for the transmission lines that linked those facilities with distant cities. This crew, pictured in 1913, is clearing land for the line between Lay Dam and Birmingham. (Courtesy of APCA.)

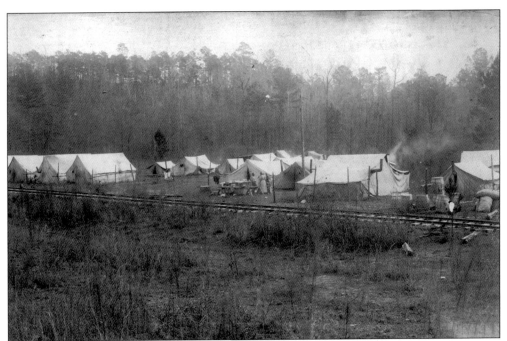

The very nature of transmission line clearing work meant that APC's workers would be spending many weeks in tents such as the ones pictured in this 1913 photograph, located somewhere between the Coosa River and Birmingham. In all, as many as 250 men were needed to build a major transmission line. (Courtesy of APCA.)

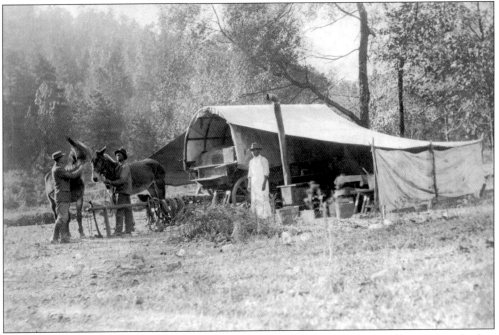

When it came time for the transmission line clearing crews to relocate their camps further down the line, they depended upon traveling wagons, such as the one depicted in this 1912 photograph in the vicinity of Lay Dam, to move the camp forward. (Courtesy of APCA.)

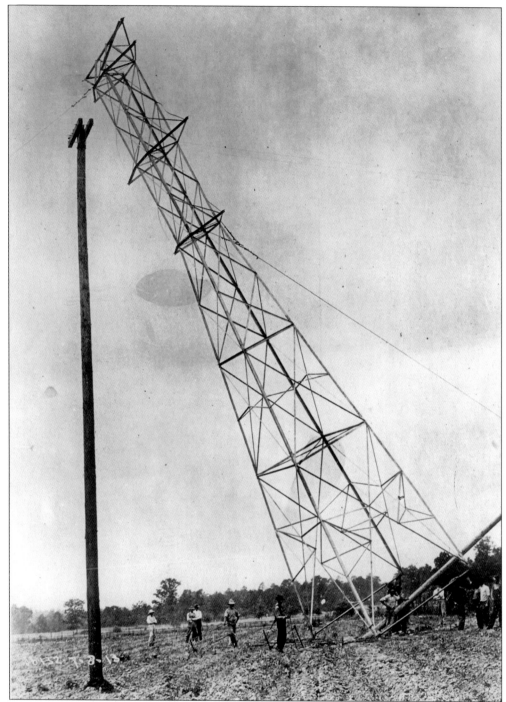

Once the transmission line right-of-ways were cleared, the next step was the erection of the transmission towers, such as this 110 kv transmission line tower shown being erected in 1913. Despite their and the company's best efforts, APC could only boast 300 miles of transmission lines in 1915. Three quarters of a century later, however, APC possessed nearly 9,000 line miles, supported by more than 112,000 poles and towers. (Courtesy of APCA.)

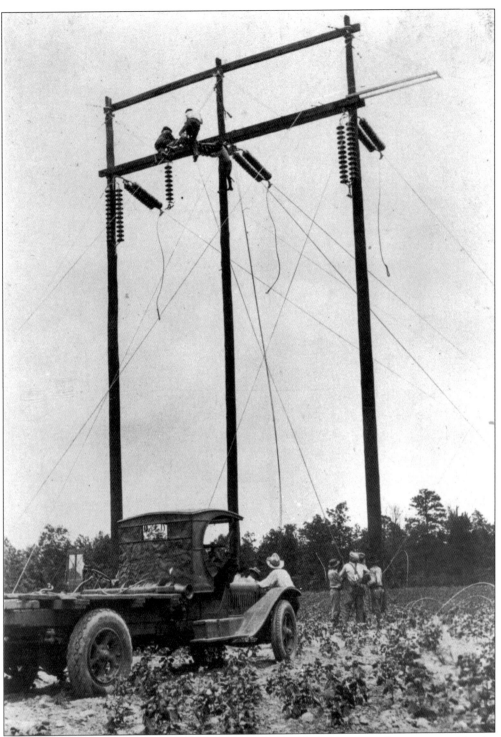

With the transmission towers in place, workers could then string the towers with the electricity-carrying wires. APC's best year of wire stringing came in 1947, when it strung 3,078 miles of rural line and connected 18,043 new homes. (Courtesy of APCA.)

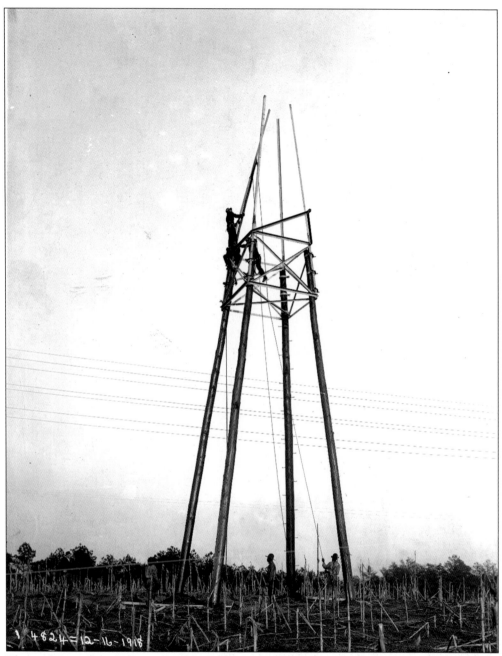

The workers in this photograph, taken in 1918, are stringing lines that will connect the Warrior Reserve Steam Plant (eventually renamed Gorgas) with the iron- and steel-manufacturing Birmingham suburb of Bessemer. (Courtesy of APCA.)

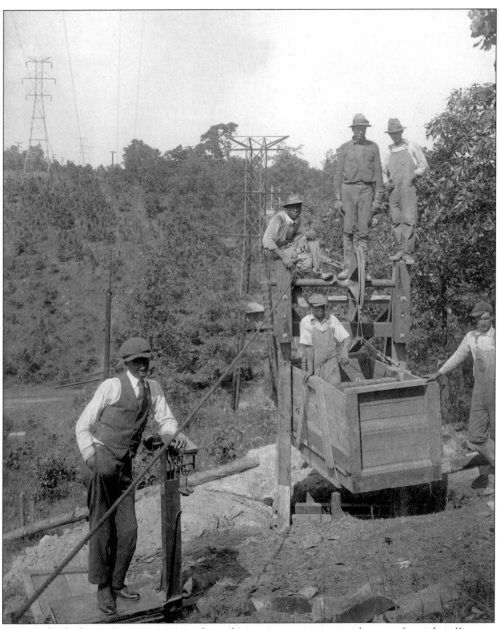

One method of stringing transmission lines from tower to tower was by use of aerial trolleys, as shown in this photograph taken in 1918 along the Warrior Reserve (Gorgas) Bessemer transmission line. (Courtesy of APCA.)

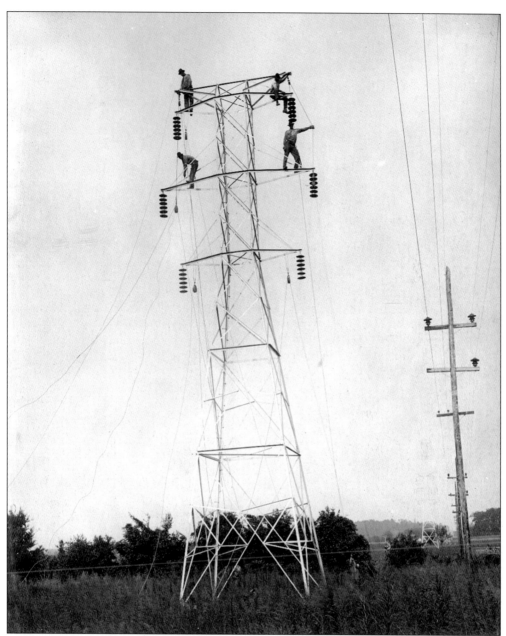

The lines being strung in this photograph would eventually connect the dam at Lock 12 (Lay Dam) with the Anniston substation pictured on page 99. The work was not over for APC's employees once the lines were installed, however. "Walking the line" to ensure continued service often entailed an overnight camping trip into the Alabama backwoods. (Courtesy of APCA.)

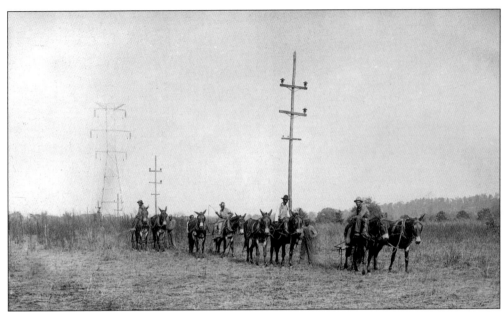

The mule team shown here in 1913 is stringing transmission line from Lock 12 (Lay Dam). The company's success in providing electricity to rural Alabama via lines such as these would earn APC the first prize ever awarded by the Edison Electric Institute for rural electrification in 1933. (Courtesy of APCA.)

The hydropower projects on the Coosa and Tallapoosa rivers were home, during the construction phase, to large villages of workers and engineers. Some homes remained to serve the smaller group of company employees who operated the dams once constructed. This house, shown in 1924, was one of those at the Martin Dam construction site at Cherokee Bluffs. (Courtesy of APCA.)

Among the 332 structures built to support the construction crews at the Martin Dam site were living quarters, an amusement hall, a church, a pool room, two mess halls, a bakery and ice plant, a barber shop, a garage, a commissary, and the two-room school pictured in this 1923 photograph. (Courtesy of APCA.)

The isolated nature of Gorgas Steam Plant necessitated on-site medical care for the company's workers. The plant had two doctors—one with an office in the basement of his on-site home and one who worked out of the plant's hospital, shown in this photograph. APC provided a doctor at the plant until the late 1960s, when workers began moving away from the plant community. (Courtesy of APCA.)

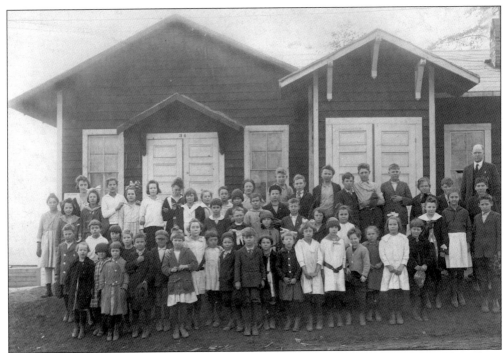

When federal funding ran out for Gorgas Steam Plant's school, the plant's superintendent, Charles Lineberry, spearheaded an effort to save the school, shown here in 1919. As part of that effort, employees took voluntary pay cuts to pay the teachers salaries and kept their children's teachers on the job. (Courtesy of APCA.)

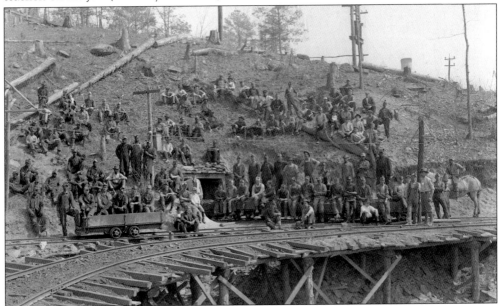

In order to keep the boilers at Gorgas Steam Plant stoked and running, massive amounts of coal had to be mined from the neighboring hills of Alabama's coal country. To accomplish this, the company relied on men such as the miners in this photograph. These men represent only half of the mine's total payroll. (Courtesy of APCA.)

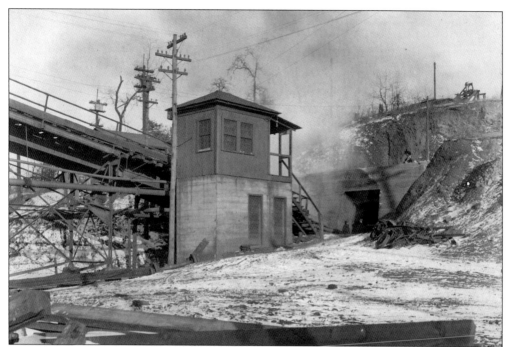

In 1915, APC opened the No. 1 Slope Mine at Gorgas Steam Plant, only one of the mines that would supply Gorgas with coal. APC operated coalmines at Gorgas until the 1970s. Its mines were known for safety and operational features such as bolts for roof control, trolley phones for communications, and other progressive mining measures. (Courtesy of APCA.)

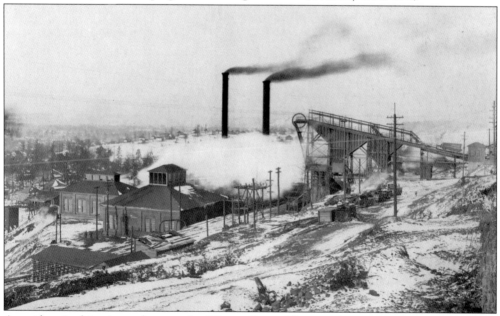

As evident in this winter photograph of Gorgas Steam Plant, coal mining and power generation in the early years of the 20th century was a dirty business. The boilers had to be hand-started with firewood, and the resulting wood and coal ash were hauled away in flatbed mining cars. (Courtesy of APCA.)

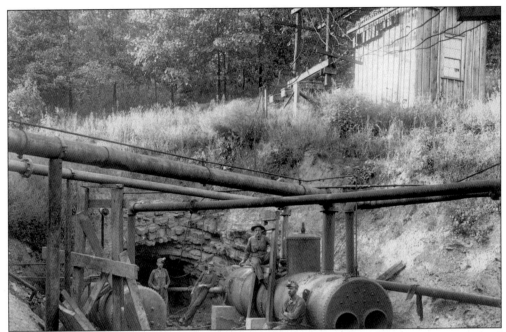

To provide the coal necessary for the operation of Gorgas Steam Plant, APC acquired thousands of acres of coal lands from the Stith Coal Company, Sloss-Sheffield Iron and Steel Company, and the Alabama Fuel & Iron Company. (Courtesy of APCA.)

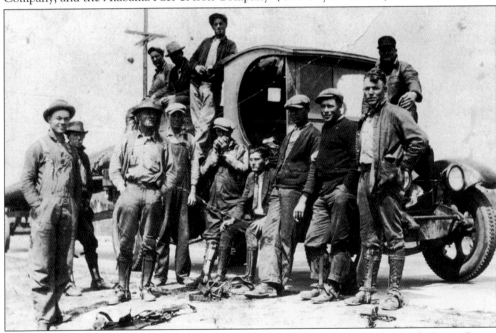

The line crew in this photograph, taken in 1912, possibly worked for the Little River Power Company, one of the local utility companies organized and chartered by Reuben Mitchell. Mitchell's company, eventually acquired by APC in 1913, was responsible for stringing a line from Talladega to Anniston in 1912. That line was the first electric line for the transmission of power connecting two cities in Alabama. (Courtesy of APCA.)

The men in this photograph, taken February 12, 1918, represented one of the two shifts of operators at Lay Dam. When one compares their number with that of the men in the preceding photograph, and with the coal miners shown on page 108, one of the allures of cheap hydropower is readily apparent. (Courtesy of APCA.)

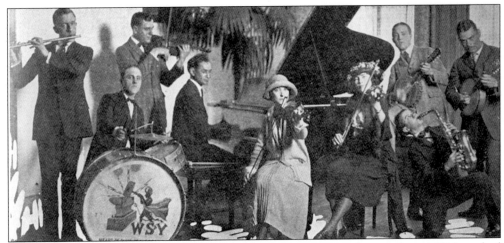

On April 24, 1922, Alabama's first licensed radio station went on the air when APC launched WSY. Intended to enable APC to keep in touch with line crews in isolated areas, the station's popularity caused APC to expand its format and include features such as music by the groups such as the WSY Orchestra, shown here. (Courtesy of APCA.)

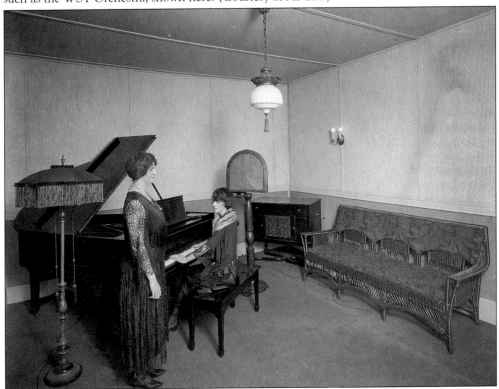

Following a day of news and performances by musicians such as the ladies shown here, WSY would sign off the air with the trademark sound of a hammer striking an anvil three times. "The anvil symbolizes the City of Birmingham, iron- and steel-working center of the South and home to WSY," the announcer would intone. "One stroke of the anvil stands for health, one for happiness and the third for prosperity. Alabama has all three in-unlimited measure." (Courtesy of APCA.)

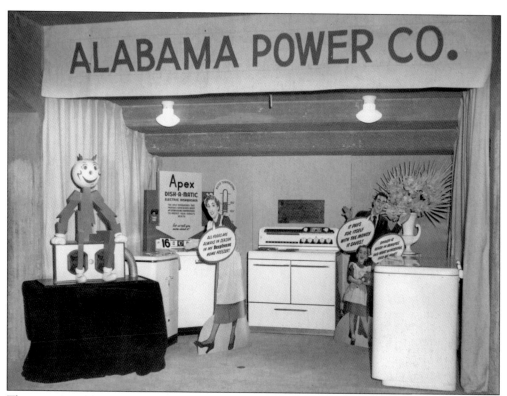

The post–World War II years saw a boom in the demand for electricity and APC's growth, fueled in part by APC's enthusiastic support (and sale) of electrical appliances such as the ones shown here at the Selma Industrial Show in 1951. (Courtesy of APCA.)

This photograph demonstrates the seriousness with which APC took its electrical appliance sales efforts in the 1950s. Here, APC salesmen undergo training on their merchandise. (Courtesy of APCA.)

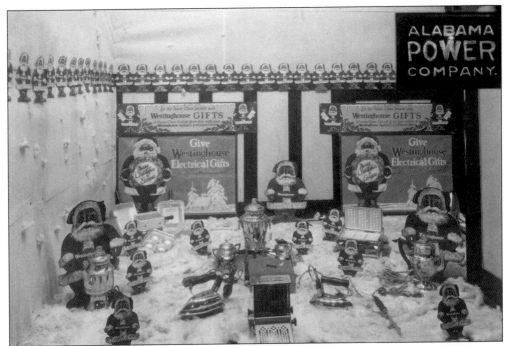

"Give Westinghouse Electric Gifts" this industrial show displayed suggested during the Christmas season. It was a gift-giving idea explicitly endorsed by Alabama Power Company—for obvious reasons. (Courtesy of APCA.)

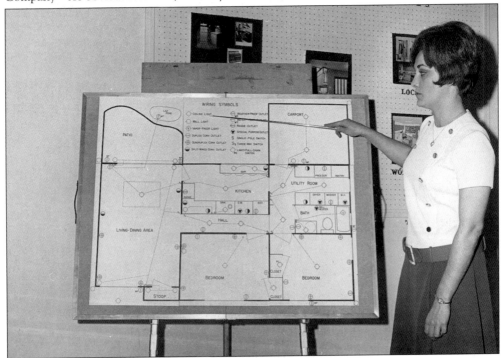

In this 1969 photograph, Phyllis Johnson participates in APC's training of its Home Service Advisors. This class involved the intricacies of home wiring and lighting. (Courtesy of APCA.)

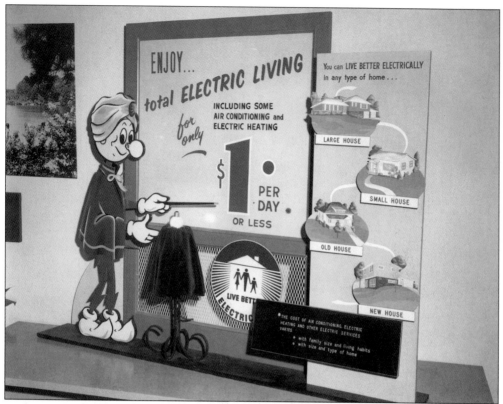

In this 1961 exhibit at the State Fair, "Reddy Kilowatt," APC's cartoon pitchman, espouses the benefits of "total electric living for only $1 per day." Reddy, eventually used as a corporate symbol by more than 200 utilities around the world from 1942 to 1973, was designed by Ashton Collins, an Alabama Power Company employee, in 1925. (Courtesy of APCA.)

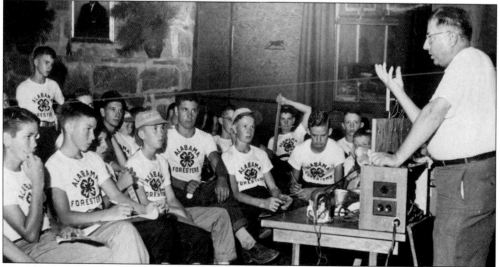

Here, APC's Hurst Maudlin teaches electric farming techniques to a local 4-H Club. Such techniques would have included innovations ranging from incubators for eggs to automatic milking machines for cows. (Courtesy of APCA.)

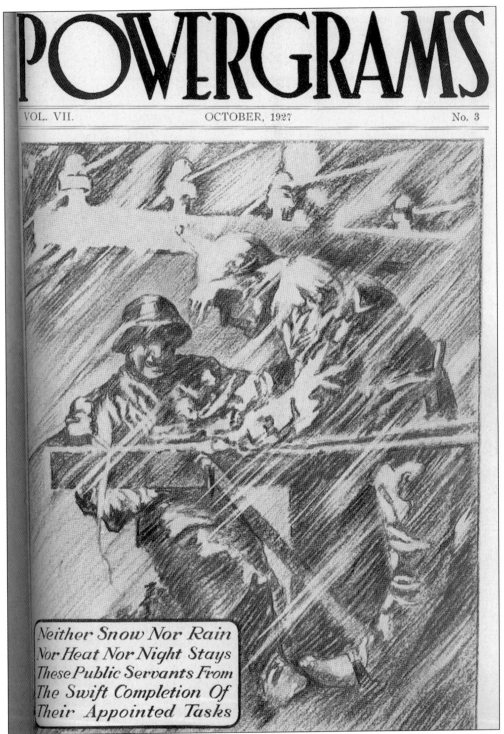

POWERGRAMS

VOL. VII. OCTOBER, 1927 No. 3

Neither Snow Nor Rain
Nor Heat Nor Night Stays
These Public Servants From
The Swift Completion Of
Their Appointed Tasks

As this October 1927 cover of *Powergrams* illustrates, APC's wiremen across the state often had to contend with the wrath of hurricanes, severe thunderstorms, tornadoes, and ice storms. (Courtesy of APCA.)

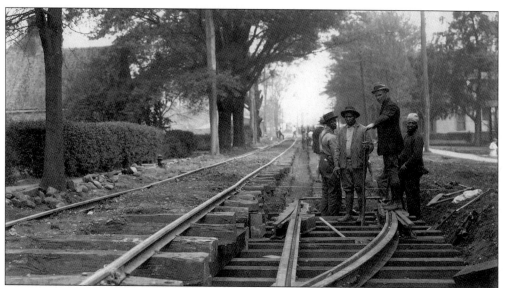

The electricity provided by APC's hydropower and coal-fired plants spurred the construction of street railways for the commuting workers of Alabama's growing industrial centers. Here, workers in 1925 install tracks for Hobson City's Oxford Street railway. (Courtesy of APCA.)

Alabama cities were making use of electric street trolleys long before APC's arrival on the scene and, in fact, Montgomery was thought to be the first city in the western hemisphere to have a citywide electric trolley system. In this 1936 photograph, Thomas Martin participates in the ceremonies marking the end of 50 years of street trolley service in Montgomery. (Courtesy of APCA.)

APC's Safety Department fielded first aid teams of men and women. Shown in this 1920 photograph, from left to right, are Flossie Nichols, Margaret Wypan, unidentified, Alma Martin, Florence Penny, and Mary Higgins. These women made up one such team. (Courtesy of APCA.)

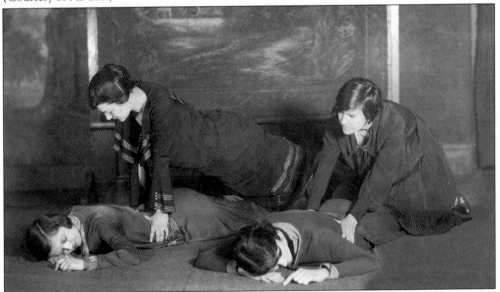

APC became recognized as a leader in exploring new methods of artificial resuscitation—an unfortunate collateral necessity given the nature of APC's chief commodity. Here, APC employees demonstrate the prone pressure method of resuscitation. (Courtesy of APCA.)

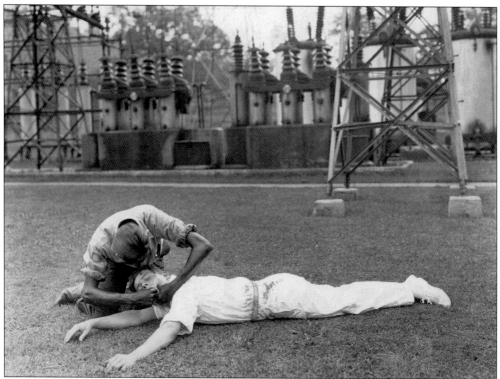

In this photograph of first aid training, a would-be resuscitator checks the mock victim's airway for signs of blockage. (Courtesy of APCA.)

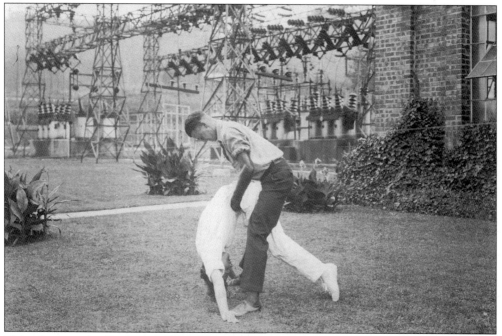

This photograph illustrates other APC first aid training—the exact nature of which is unknown. (Courtesy of APCA.)

For many years, APC maintained a full-time medical staff to doctor its employees and respond to accidents. Among the staff was Mary Martin, shown here in 1958 prepared to tend any of the estimated 12,000 guests at the Weiss Dam groundbreaking ceremonies. (Courtesy of APCA.)

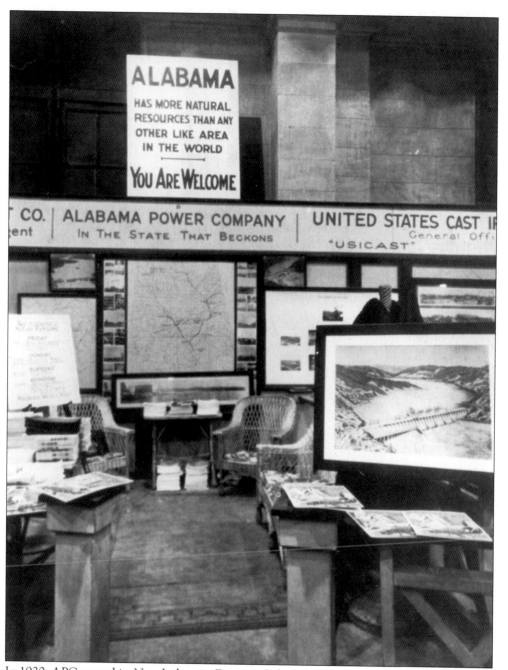

In 1920, APC started its New Industries Division, believed to be the first utility-based division of its kind in the United States. The division, using methods such as displays at this trade show in Boston in 1921, focused on the recruitment of new industries (who would, in turn, become new customers of APC) to Alabama. (Courtesy of APCA.)

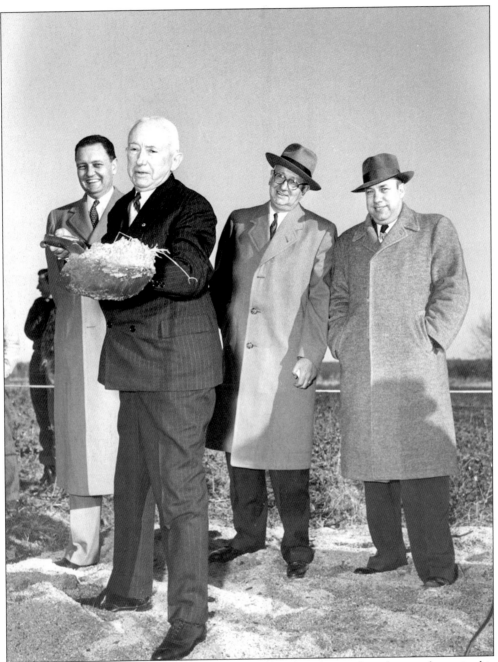

The success of the New Industries Division was evident at events such as the one shown in this photograph in 1951. Here, from left to right, Congressman Carl Elliot, Thomas Martin, R.A. Corvey, and W.E Parror participate in a ceremonial groundbreaking at Westinghouse's new facility in Reform, Alabama. (Courtesy of APCA.)

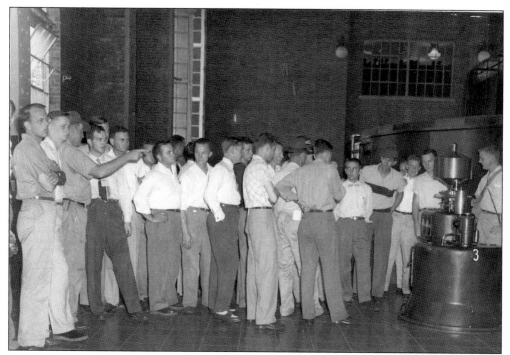

Continuing a tradition that had started with the construction of its earliest hydropower projects, APC hosted this group of Auburn University engineering students at Yates Dam on May 6, 1950. Here, APC employees discuss the dam's No. 1 generating unit with the students. (Courtesy of APCA.)

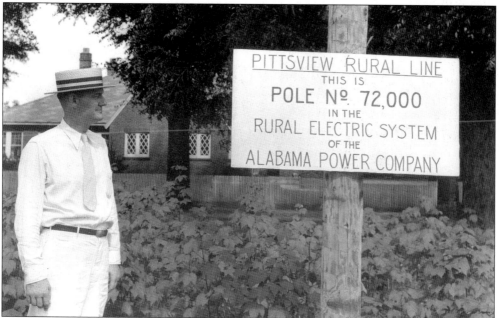

This photograph shows C.T. Hunter, the manager of APC's Southeast Division, celebrating the placement of APC's 72,000 pole in its rural electrification program. This milestone came in August of 1935. (Courtesy of APCA.)

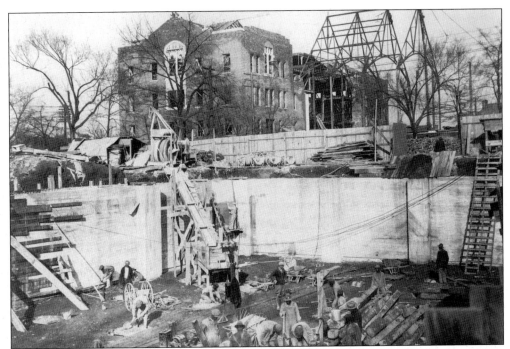

APC's first general offices were located in Montgomery. In 1912, the young APC moved those offices to Birmingham, taking up occupancy in downtown Birmingham's Brown-Marx Building. Larger quarters were needed, and in October 1924, APC began construction of a new corporate headquarters at the corner of Sixth Avenue North and Eighteenth Street. (Courtesy of APCA.)

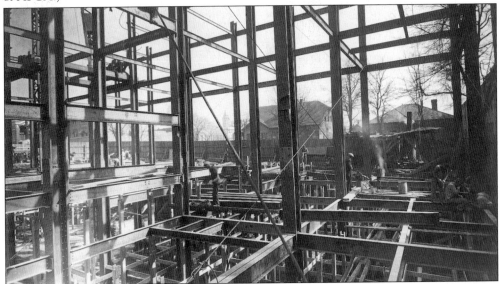

APC used its subsidiary, the Dixie Construction Company, as the construction project's general contractor. The Birmingham firm of Warren-Knight & Davis served as the project's architects, although at the urging of APC's then–general manager E.A. Yates, Warren-Knight & Davis retained the services of 30-year-old Sigmund Nesselroth, a New York architect, who was the building's primary designer. (Courtesy of APCA.)

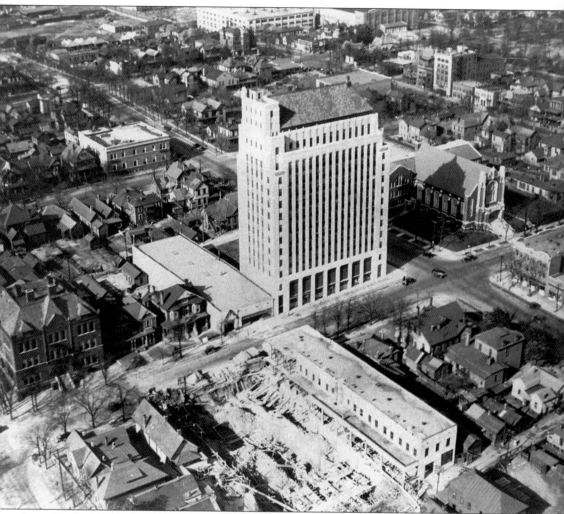

Completed in 1925, the new corporate headquarters represented a departure from the "Chicago style" skyscrapers that had been built in the city to that date. Rather, Nesselroth's design illustrated the emerging "New York style," with its telescoping design, sculptured form, and sloping roof. In the end, he produced what was recognized as the first Neo-Gothic Art Moderne commercial building in the southeastern United States. (Courtesy of APCA.)

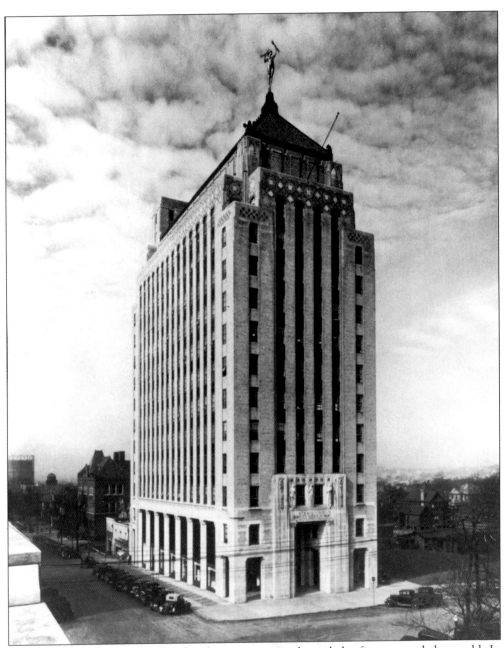

Alabama Power Company's new headquarters received accolades from around the world. In 1925, a London newspaper pronounced it to be one of the three most beautiful public buildings in the world. APC bathed in its accolades and proudly pointed out that practically all of the 13-story building's materials—steel, iron, brick, granite, and limestone, for example—had come from within a 60-mile radius of its location in downtown Birmingham. (Courtesy of APCA.)

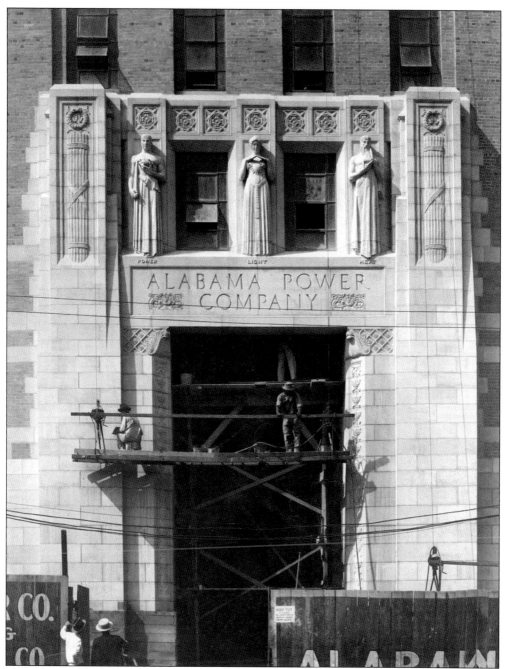

Another distinction found in the corporate headquarters was the use of outside decorative sculpture on its façade. New York sculptor Edward Field Sanford Jr. designed the three eight-foot-high figures that form the triptych of *Power, Light and Heat* above the building's main entrance. Sanford's other credits include work on the California State Capitol Building in California. (Courtesy of APCA.)

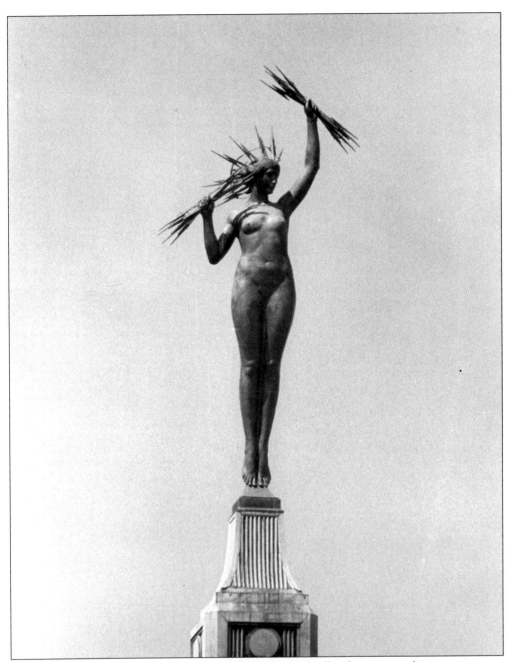

Architect William Warren succeeded in convincing APC officials to crown the new corporate headquarters with the 16-foot-high, gold-leafed statute of Electra rather than a 13-foot-high electric sign running along its roof ridge as originally proposed. Reportedly, the idea for Electra was inspired by the position of Diana atop New York's Madison Square Garden Building, a project upon which Warren had received his early training. (Courtesy of APCA.)